100 ARTISTS SEE SATAN

GRAND CENTRAL PRESS
Santa Ana, California

LAST GASP
San Francisco, California

"Master of Puppets, I'm pulling your strings.

Twisting your mind and smashing your dreams

Blinded by me, you can't see a thing.

Just call my name, cause I'll hear you scream."

Metallica Master of Puppets

Better to reign in Hell

W ARE, MORE FOR GOOD ILL,
WHAT AIM HATH ACT?
WITHOUT ITS CLIMAX, DEATH,
WHAT SAVOUR HATH LIFE?
AN IMPECCABLE MACHINE, EXACT
HE PACES AN INANE AND POINTLESS PATH
TO GLUT BRUTE APPETITES, HIS SOLE CONTENT
HOW TEDIOUS WERE HE FIT TO COMPREHEND
HIMSELF! MORE, THIS OUR NOBLE ELEMENT
OF FIRE IN NATURE, LOVE IN SPIRIT, UNKENNED
LIFE HATH NO SPRING, NO AXLE, AND NO END.
HIS BODY A BLOOD-RUBY RADIANT
WITH NOBLE PASSION, SUN-SOULD LUCIFER
SWEPT THROUGH THE DAWN COLOSSAL,
SWIFT ASLANT ON EDENS IMBECILE PERIMETER.
HE BLESSED NONENTITY WITH EVERY CURSE
AND SPICED WITH SORROW THE DULL OF SENSE,
BREATHED LIFE INTO THE STERILE UNIVERSE,
WITH LOVE AND KNOWLEDGE
DROVE OUT INNOCENCE
THE KEY OF JOY IS DESOBEDIANCE.

ALEISTER CROWLEY
HYMN TO LUCIFER

JOHN
MILTON
PARADISE
LOST

Than to serve in Heaven

CURATOR'S FOREWORD

SEEING SATAN
by Mike McGee

In the course of promoting his recent movie, *The Passion of the Christ* (2004), Mel Gibson told talk-radio and television show host and political pundit Bill O'Reilly, "Evil pervades certain areas and comes to each of us in an individual way, in a way that it's going to best ensnare us. Firstly, it wants to make you believe that it doesn't exist. And secondly, I think, when it does come it's going to come in a magnetic form. I mean it's not going to be holding a neon sign with steam coming out its nostrils."[1] If Warhol were alive, I'm sure he would be elated that our culture has reached a point where celebrity patter is granted the weight of theological discourse.

Among the many possible explanations of evil, I have always liked the one that mythology expert Joseph Campbell gave Bill Moyers in the PBS interview series The Power of Myth: "The monster masks that are put on people in Star Wars represent the real monster-force in the modern world. When the mask of Darth Vader is removed you see an unformed man, one who has not developed as a human individual. He's a bureaucrat, living not in terms of himself, but in terms of an imposed system."[2]

Princeton University professor and Biblical scholar Elaine Pagels in her book *The Origins of Satan* asserts that Satan, as we know him today, was born just after the death of Christ.[3] While Satan may have derived from Zoroastrianism's Angr Manyu (or Ahriman), the evil twin brother of monotheistic Ahura Mazda, the creator of all things, and may have roots in the Hebrew Bible, Pagels suggests that his development occurred largely to address the social and political needs of early Christians and some first-century Jewish groups (primarily the Essenes) to vilify and distance themselves from those who opposed them—the ubiquitous "other."

Clement of Alexandria (c. 150-213) was the first of many Christian writers to categorize the gods and spirits of all non-Christian belief systems as demons and agents of Satan. Early Christianity's focus on The Fall led to the conclusion that only the spirit is good and all things of this material world, including flesh, are evil. We can thank Saint Augustine (345-430) for further aligning Satan and his demons with sexual desire, and Thomas Aquinas (1225-1274) and other Christian thinkers for reinforcing the idea.

Since the Enlightenment, faith in science and empirical experience has fueled a consistent erosion of belief in all things non-material; in contemporary Western culture we have increasingly assumed a much less literal interpretation of the spiritual plane. Although 35% of Americans today believe Satan is a living being,

most Americans view Satan as a symbol of evil.[4] It is fair to say that we don't take Satan as seriously we once did; the last "heretic" burned alive at the stake went up in flames in Poland in 1792, and the Catholic Church officially disbanded the office of Exorcist in 1972. Rumors of Satanic ritual abuse (which gained the status of acronym in the 1980s—SRA) have turned out to be more hoax and hysteria than fact; Michelle Remembers (1980)[5], the first in a series of books about satanic ritual abuse, has been roundly debunked, as have subsequent accounts of SRA. Even the ritual child abuse alleged in the McMartin preschool case in the late 1980s turned out to be the result of unintentional "implantation of false memories" by police, social workers, and psychologists. The Church of Satan founded in San Francisco in 1966 by purported former circus hand, Anton Levy (1930–1997), despite vacillating popularity, seems to be more sideshow than religion.

However, Walter Wink, pacifist and professor of Biblical Interpretation at Auburn Theological Seminary, New York, claims in his 1998 book The Powers that Be that everything, not just individuals and nations, but "every business, corporation, school, denomination, bureaucracy, [and] sports team," has a spirit. According to Wink, "when a particular Power becomes idolatrous . . . then that Power becomes demonic."[6]

One of the most elegant and poignant statements of our time about the role Satan might play relative to the individual psyche can be found in the title poem from Sharon Olds' celebrated first anthology, Satan Speaks[7]:

Satan sucks himself out of the keyhole.
I'm left locked in the box he seals
the heart shaped lock with the wax of his tongue.
It's your coffin now, Satan says.
I hardly hear;
I am warming my cold
hands at the dancer's
ruby eye—
the fire, the suddenly discovered knowledge of love.

Since the Middle Ages, Satan and his derivatives and demons have been popular subjects for visual artists. Depictions of satyrs, and Pan specifically, in Greek and Roman art are the source of many of the visual characteristics we attribute to Satan today. The image, of course, also appears in book illuminations and the stone reliefs on medieval cathedrals. Paintings incorporating representations of Satan become notable in the fifteenth and sixteenth centuries. Perhaps the most famous are Hieronymous Bosch's surreal depictions of tortured souls, but other artists of that time, such as Pieter Bruegel the Elder, created memorable images of Satan. One image that has stuck in my mind form my earliest studies of art history is that by Austrian artist Michael Pacher in his painting The Devil Shows the Book of Sins to Saint Augustine (1483), in which Satan is shown as an angular green reptilian figure with human characteristics and animal hoofs, his tail a nose to his anus/mouth, and his eyes situated on his thin butt cheeks. (I would later think of Pacher's Satan as a slim version of the beast in Ridley Scott's movie Alien (1979)).

Luca Signorelli created some unforgettable images of Satan and his demons engaged in sadistic tortures, as did Giorgio Vasari and Federic Zuccari, a century later, on the cupola fresco of the Duoma Santa Maria del Fiore in Florence (1572–1579). But the most dynamic images of Satan and his demons in

Renaissance art are those found in Michelangelo's *The Last Judgment* on the wall of the Sistine Chapel (1537-1541).

Peter Paul Rubens, Nicolas Poussin, and other seventeenth-century artists depicted images of Pan and other satyrs entwined with nymphs in Bacchanalian splendor, a theme that proved popular well into the nineteenth century, when the tradition was carried on by Adolphe-William Bouguereau and other late-academic painters. Near the end of the eighteenth century, Francisco Goya created his personalized variation of goblins and demons in the Los Caprichos engravings. In the nineteenth century, the image of Satan was used to sell products, particularly in Paris, where the devil appeared in advertisements for the Folies-Bergère and for products such as alcohol and ink.

The use of Satan's image in advertising continued throughout the twentieth century and beyond. References to the devil and Satan in music and films were constant through the twentieth century and especially frequent in the latter part of the century. (Mick Jagger singing "Please allow me to introduce myself . . ." in 1968 and Al Pacino's portrayal of Satan in *The Devil's Advocate* (1997) are indelible components of the American lexicon.) Satan's most common role during the twentieth century may have been as a character in jokes; the Prince of Darkness as a tool to effect smiles and laughter is probably the most visible function of the devil in contemporary culture. In the fine art arena, the depiction of Satan became less common in the twentieth century than it was previously, until the final decades of the millennium.

100 Artists See Satan is a survey of contemporary artists and their interpretation and representation of the supreme demon. The exhibition was organized in response to another exhibition, *100 Artists See God*, organized by artists/curators John Baldessari and Meg Cranston for Independent Curators Inc., New York. During roughly the same period that *100 Artists See Satan* is showing at the Cal State Fullerton Grand Central Art Center in Santa Ana, *100 Artists See God* will be on view at the Laguna Art Museum in Laguna Beach.

Mark Twain once said, "All religions issue Bibles against Satan, and say the most injurious things against him, but we never hear his side." While *100 Artists See Satan* may not exactly present Satan's side of things, it does present a wide, albeit inconclusive, range of perspectives; it is intended to be a series of snapshots and ruminations, and it is an essentially visual exercise—there are no artist biographies or artist statements in the catalogue, just images by 100 artists. (Actually 115 artists' works are included in the catalogue and probably a few more in the exhibition; we attribute this to Satanic math, but it also had a lot to do with having an abundance of good work that we wanted to include in the exhibition). Some of the artists are famous and some unknown; their approaches to Satan range all over the place, from humor and absurdity to deadpan seriousness, from blatantly political to esoterically philosophical, from text to symbolic images, from art historical references to pop-culture icons, from overt graphic images to subtle, sometimes poetic gestures, from abstraction to explicit depictions of individuals or imagery, from the found object to the meticulously rendered painting, from drawing to photography to video to music.

Although I am the official curator of this exhibition, *100 Artist See Satan* was decidedly a group project. Many people contributed to this project—quite a few recommended artists—but Greg Escalante, Stuart Spence, and Grand Central Art Center director Andrea Harris are the three main collaborators. As is becoming the rule for exhibitions at the Grand Central Art Center, Andrea did the bulk of the organizational work. Greg and Stuart repeatedly reviewed our list of artists, made suggestion, and then followed up by contacting the artists. Stuart and Judy Spence also generously donated funds to produce this publication.

The concept for *100 Artists See Satan* was developed by the Grand Central Forum Board, the support group for the Art Center. Although I believe it was board chairman Shelley Liberto who first had the light-bulb flash to organize *100 Artists See Satan*, most of the other members of the board quickly acknowledged it as a good idea and contributed in significant ways, including Marcus Bastida, Teri Brudnak, Don Cribb, Jon Gothhold, John Gunnin, Mary Ellen Houseal, Dennis Lluy, and Mike Salisbury and Mitchell DeJarnett, both of whom participated in the project as exhibiting artists. I also want to thank Cal State Fullerton research librarian Suellen Cox for her assistance and input, and Marilyn Moore for her moral support and help with this project. The rest of the staff at the Grand Central Art Center also put forth an extraordinary effort—this is the first time (and possibly the last) that the art center has presented a project with more than 100 artists.

I also want to thank Cal State Fullerton professor Theron Moore for being the art director for this devilishly beautiful catalog. Moore and the students he worked with—Josh Barney, Andrea Herbold, Brian Lindstrom, Eric Lumba, Tanya A. Ortega, and Erik Nagashima—devoted a level of energy and creativity to this project that is far beyond the normal classroom exercise.

And finally, I want to thank the artists. Putting together a project with so many artists is logistically difficult. But I can't recall ever working on a project were so many artists were so enthusiastic about being involved and so prompt and cooperative in meeting deadlines. Although there are a number of older works in this exhibition, I was surprised by the number of artists who wanted to make new works. (I will avoid speculating here as to exactly what inspired them.) We are indebted to all the artists in this exhibition for the energy and excitement they have brought to this project in addition to making it all possible.

This essay was written on Easter Sunday, April 11, 2004, in Santa Ana, California.

Mike McGee is the director of the Main Art Gallery at Cal State Fullerton.

NOTES

1 *Bill O'Reilly show*

2 *This is actually the caption next to the picture of Darth Vader on page 145 in the book The Power of the Myth (Doubleday, 1988) —a transcription of the original televised interviews. The caption paraphrases Campbell's remark.*

3 *Eileen Pagels, The Origins of Satan, New York: Knopf, 1996.*

4 *"Americans Draw Theological Beliefs from Diverse Points of View," Barna Research Online, 2004-April-8, at http://www.barna.org/FlexPage.aspx?Page=Topic&TopicID=6, based on a 2001 survey.*

5 *Michelle Smith and Laurence Pazder, M.D., Michelle Remembers, New York: Congdon & Lattes, 1980.*

6 *Walter Wink, The Powers That Be, New York: Galilee, 1999, p.50.*

7 *Sharon Olds, "Satan Speaks," Satan Speaks, University of Pittsburgh Press, 1980.*

Peter Zokosky	Roland Reiss	F. Scott Hess	Coop
Paul Zelevansky	Kenny Price	Mark Hersey	Joe Coleman
Liz Young	The Pizz	Anaida Hernandez	Dan Clowes
Robert Williams	Raymond Pettibon	George Herms	Colin Chillag
William T. Wiley	Manuel Pardo	Laurie Hassold	Amy Caterina-Barrett
William Wegman	Naida Osline	Don Ed Hardy	Scott Marvel Cassidy
Mary Hull Webster	Enjeong Noh	Rick Griffin	Kalynn Campbell
Marnie Weber	Martin Mull	Scott Grieger	Bill Burns
Jeffrey Vallance	Patrick Merrill	Alex Grey	Chris Burden
John Valadez	Mear	Stuart Gow	David Bunn
Richard Turner	Dean McNeil	Mat Gleason	Jonathan Borofsky
Haruko Tanaka	Ryan McNamara	Jeff Gillette	Chaz Bojorquez
Stanislav Szukalski	Michael C. McMillen	Gregg Gibbs	Sandow Birk
John Swihart	Michael P. McManus	John Geary	Cliff Benjamin
(w/John Frame)	Elizabeth McGrath	Bia Gayotto	Gary Baseman
Cory Stein	Barry McGee	Steve Galloway	Van Arno
Craig Stecyk	Janice Lowry	Paul Frank	Franco Angeloni
Brian Smith	James Lorigan	Llyn Foulkes	Kevin Ancell
Jim Shaw	Bad Otis Link	Enzia Farrell	Terry Allen
Shag	Don Lagerberg	Extremo	Jo Harvey Allen
Ilene Segalove	Paul Laffoley	Jason Dugan	Bale Creek Allen
Dustin Schuler	Diana Kunce	Einar de la Torre	John Alexander
Kenny Scharf	Charles Krafft	Jamex de la Torre	Peter Alexander
Mike Salisbury	(w/Warner Lindholm)	Tony DeLap	Lita Albuquerque
(w/Clive McClean)	Frank Kozik	Mitchell De Jarnett	Rev. Ethan Acres
Saber	Michael Knowlton	Robert Crumb	Kim Abeles
Mark Ryden	Tom Knechtel	Russell Crotty	
Ed Ruscha	Martin Kersels	Sarah Cromarty	
Erika Rothenberg	Mike Kelley	Rosemary Covey	
Rachel Rosenthal	Seth Kaufman		
Boyd Rice	Jim Jenkins		
Victoria Reynolds	James Hill		

Artist List

Unless otherwise noted all artworks courtesy of the artist

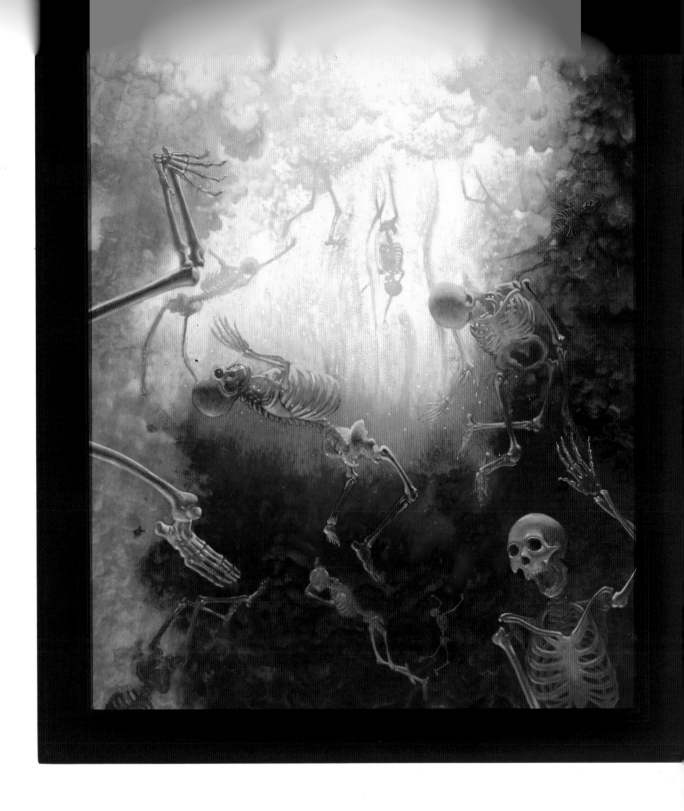

Peter Zokosky

COMBUSTION, 1997
Oil on canvas
36" x 31"

American Family Association
America's Pro-Family Online Activism Organization

Take Our Online Poll

Please select one of the four poll choices, complete the form (all fields required), and click the submit button. Results of this poll will be presented to Congress.

America's Poll on Homosexual Marriage

○ I oppose legalization of homosexual marriage and "civil unions"

○ I favor legalization of homosexual marriage

○ I favor the sterilization of "christian" fundamentalists

○ I favor a "civil union" with the full benefits of marriage except for the name

First Name: []

Last Name: []

E-Mail: []

U.S. State: [▼]

Zip/Postal Code: []

[Submit]

Paul Zelevansky

MARRIAGE POLL, 2004
Digital Print· (altered internet screen clip)
Variable dimensions

Liz Young

THE TAIL OF SHIRLEY DE CADE, 2002
STILL FROM VIDEO

Robert Williams

PERINEUM TARTARE, 1987
MUSEUM CATALOG TITLE: "ALL HOPE ABANDON YE WHO EAT HERE" BECAUSE ON THE PICNIC
PORCH AT THE GATES OF HELL ONLY THOSE WHO HAVE SOWED MISERY FOR PROFIT CAN EAT
RED MEAT WITH THE DEVIL AND TAKE UP THE ACCURSED BARBECUE APRON TO SIDE WITH HIM
WHOSE STEAK IS NEVER DONE
COLLOQUIAL TITLE: HIBACHI MUFF FLAMBEAU
OIL ON CANVAS
30" X 36"
COLLECTION OF THE PIZZ

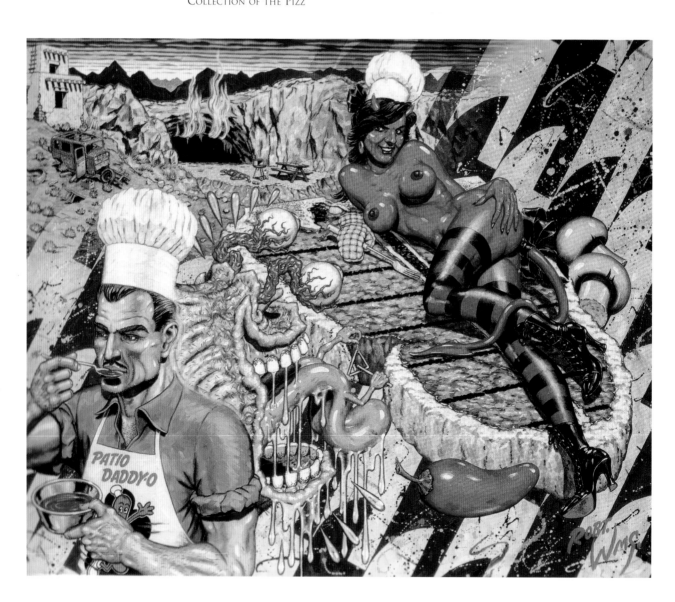

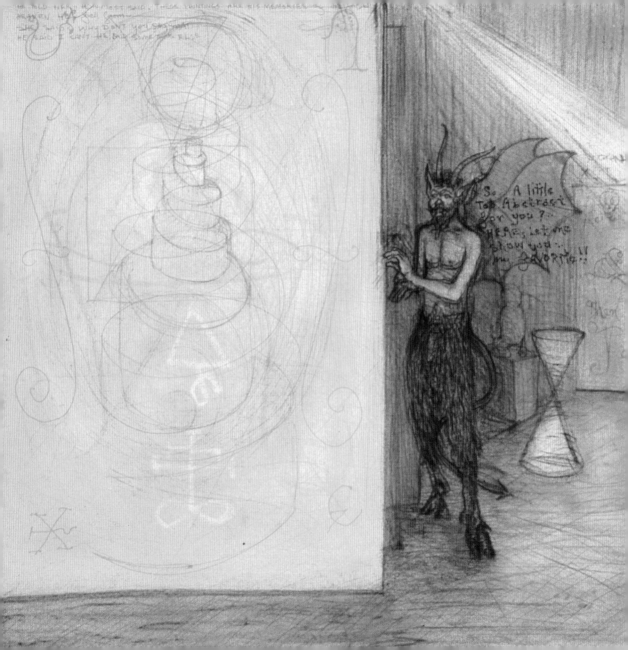

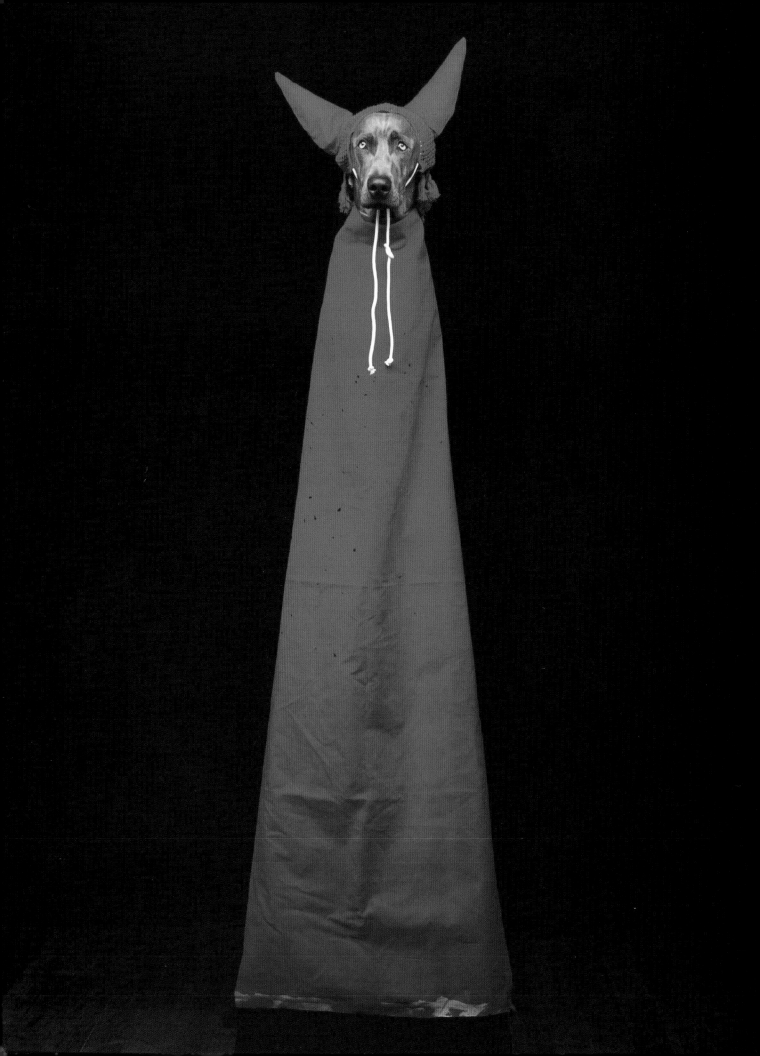

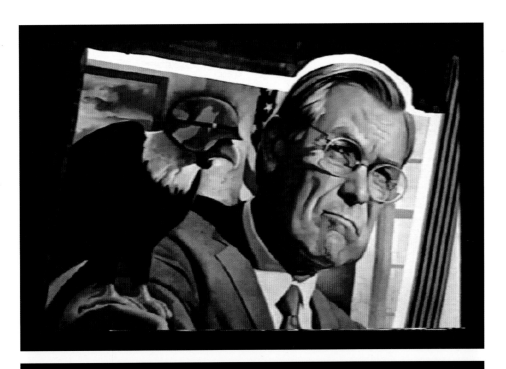

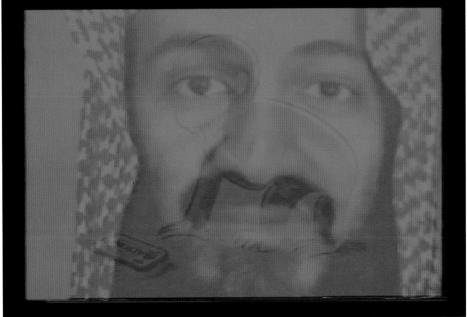

Mary Hull Webster

TIME'S MAN OF THE YEAR, 2001
DVD, SILENT VIDEO
3:04 MINUTES

William Wegman

TIES WITH DEVIL, 1990
COLOR POLAROID
24" x 20"
FAY AS DEVIL

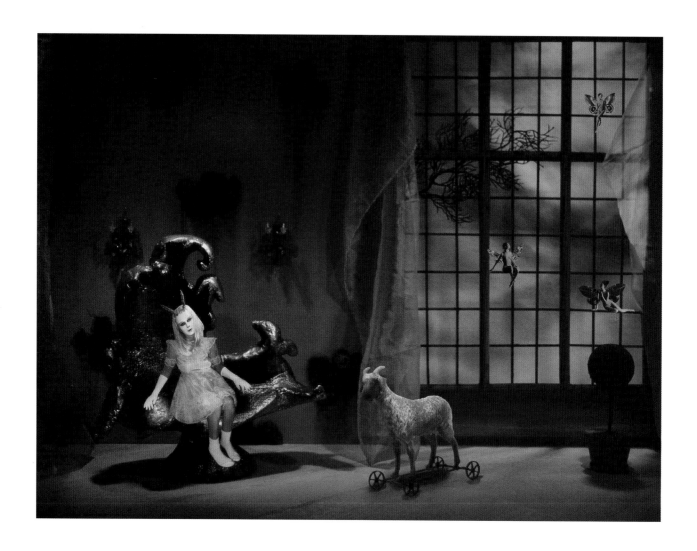

MARNIE WEBER

GOAT GIRL, 2004
COLLAGE ON PHOTOGRAPH
32" x 24"
COURTESY OF MARNIE WEBER AND FREDERICKS FREISER GALLERY, NEW YORK

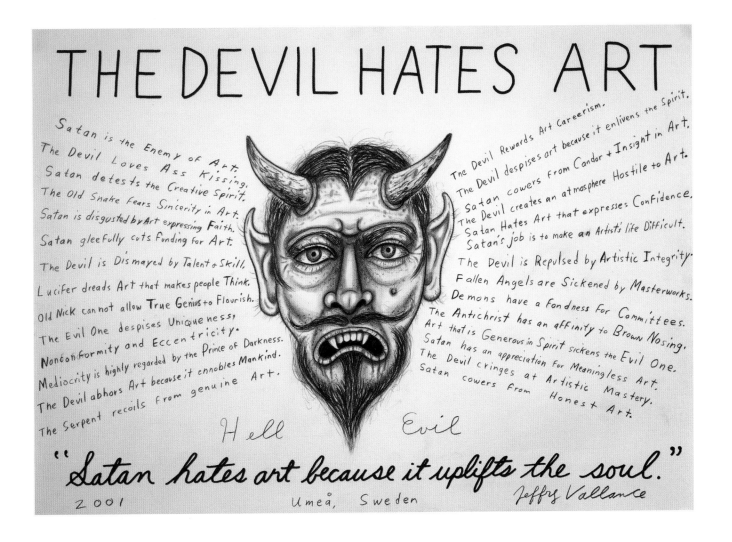

THE DEVIL HATES ART

Satan is the Enemy of Art.
The Devil Loves Ass Kissing.
Satan detests the Creative Spirit.
The Old Snake fears Sincerity in Art.
Satan is disgusted by Art expressing Faith.
Satan gleefully cuts Funding for Art.

The Devil is Dismayed by Talent & Skill.
Lucifer dreads Art that makes people Think.
Old Nick cannot allow True Genius to Flourish.
The Evil One despises Uniqueness,
Nonconformity and Eccentricity.
Mediocrity is highly regarded by the Prince of Darkness.
The Devil abhors Art because it ennobles Mankind.
The Serpent recoils from genuine Art.

The Devil Rewards Art Careerism.
The Devil despises art because it enlivens the Spirit.
Satan cowers from Candor + Insight in Art.
The Devil creates an atmosphere Hostile to Art.
Satan Hates Art that expresses Confidence.
Satan's job is to make an Artists life Difficult.

The Devil is Repulsed by Artistic Integrity.
Fallen Angels are Sickened by Masterworks.
Demons have a Fondness for Committees.
The Antichrist has an affinity to Brown Nosing.
Art that is Generous in Spirit sickens the Evil One.
Satan has an appreciation for Meaningless Art.
The Devil cringes at Artistic Mastery.
Satan cowers from Honest Art.

Hell Evil

"Satan hates art because it uplifts the soul."

2001 Umeå, Sweden Jeffry Vallance

JEFFREY VALLANCE

THE DEVIL HATES ART, 2001
Pencil and pen on paper
19 3/4" x 27 1/2"
Collection of Rachel and Jean Pierre Lehmann
Photo by Bill Orcutt Photography

I have often wondered why the artist's life is so difficult. The cause of this dreadfull syndrome becomes clear if you see art as one of humanity's finest accomplishments. It can uplift the spirit, leading to higher ideals or even bliss. Evil cannot allow it to prosper. It's hard to make art because Satan hates good art!

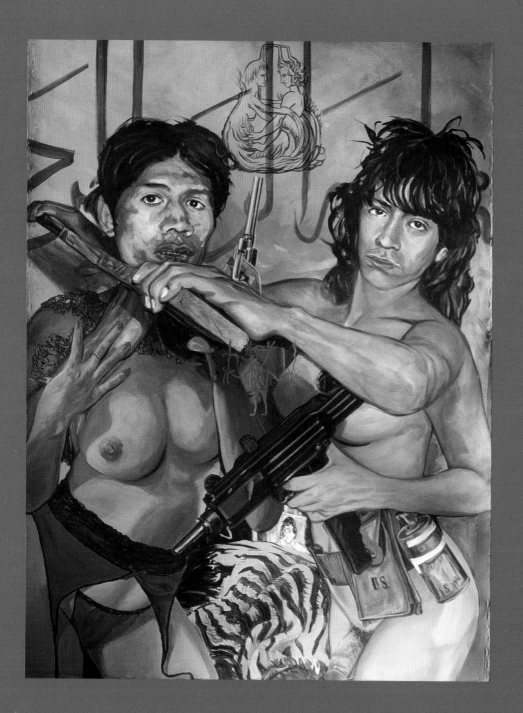

John Valadez

LAS MALDOSAS, 1995
Acrylic on canvas
78" x 57"

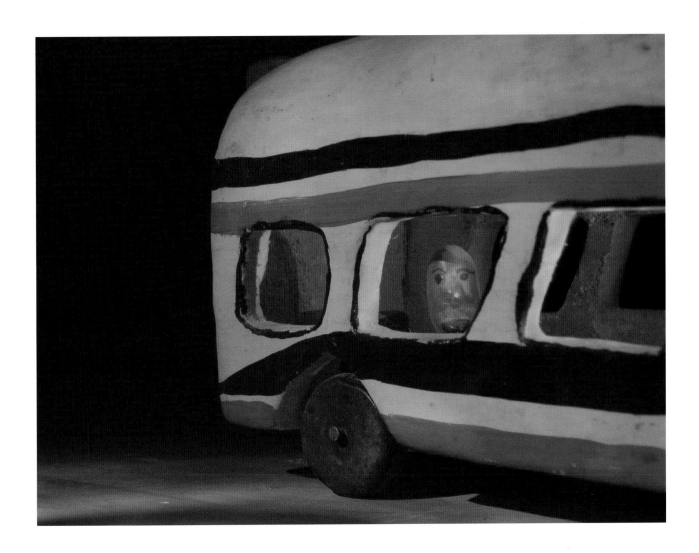

Richard Turner

THE BUS RIDE FROM HELL, 2004
Variable media
Variable dimension

Haruko Tanaka

STUDIES FROM - MOKUTOU (SILENT PRAYER), 2004
VIDEO STILLS

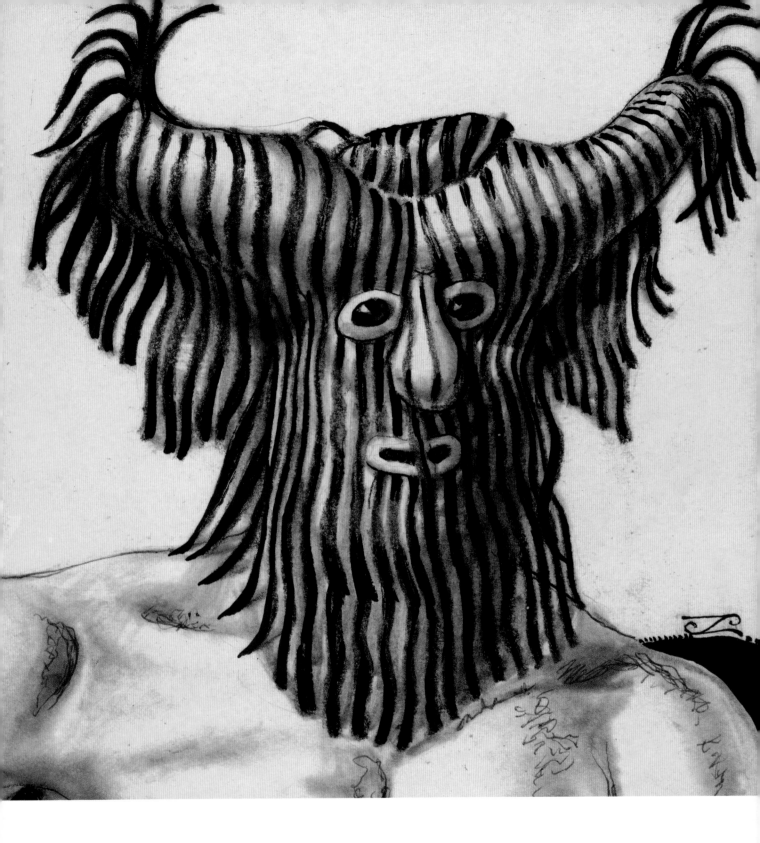

Stanislau Szukalski

UNTITLED, c. 1965
Ink & pencil on paper
7 1/4" x 7 1/2"
Glenn Bray Collection

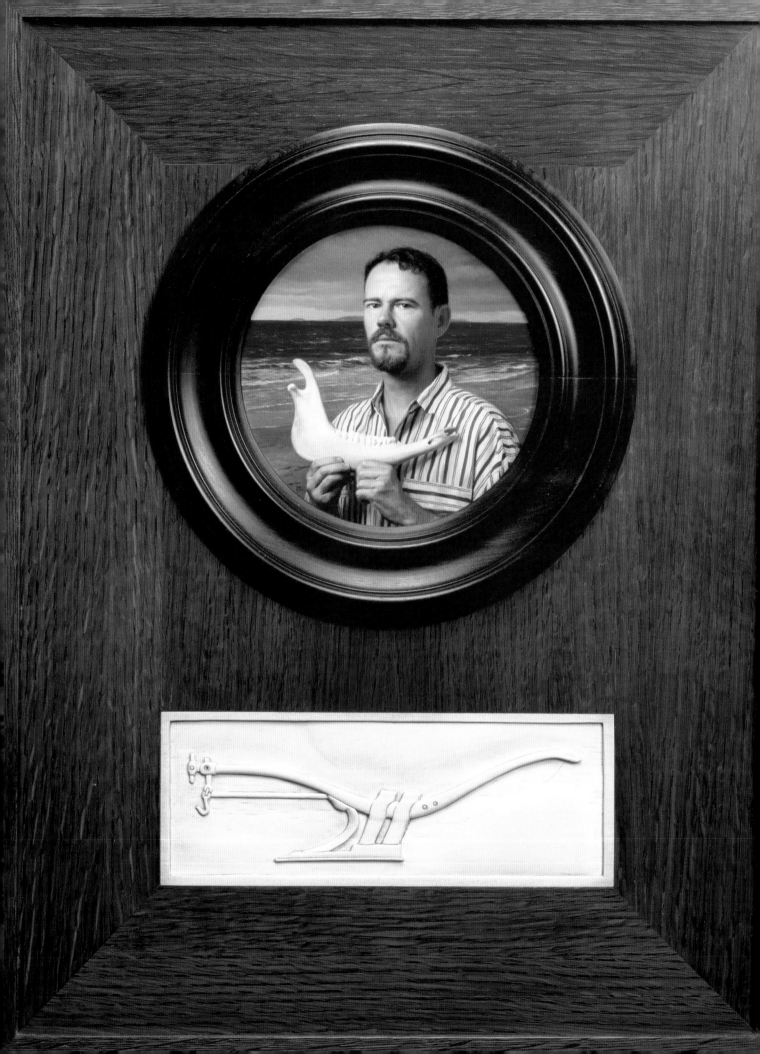

John Swihart (painting)
John Frame (frame)

SHIPPING FOR THE ISLE OF DOGS, 1995
PORTRAIT OF F. SCOTT HESS
OIL ON PANEL
5 1/4" (TONDO)
PRIVATE COLLECTION

Cory Stein

PARTNERS IN PRACTICE, 1998
ACRYLIC ON SATIN
10" x 8"
PHOTO BY M.O. QUINN

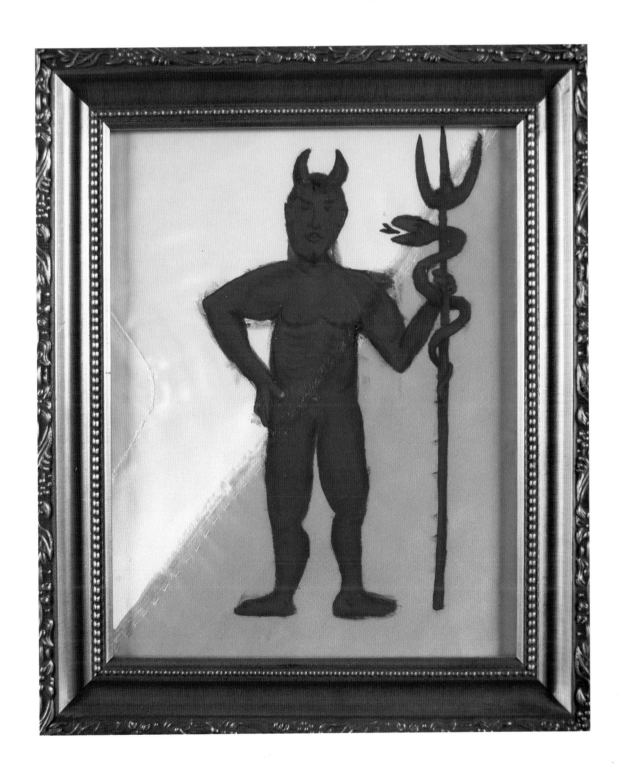

CRAIG STECYK

SATAN RIDES ALONE, 2004
MIXED MEDIA
48" x 72" x 10"

Brian Smith

UNTITLED, 1989
Mixed media
48" x 48"
In Memory of Rob Weiss
Collection of Gary Pressman

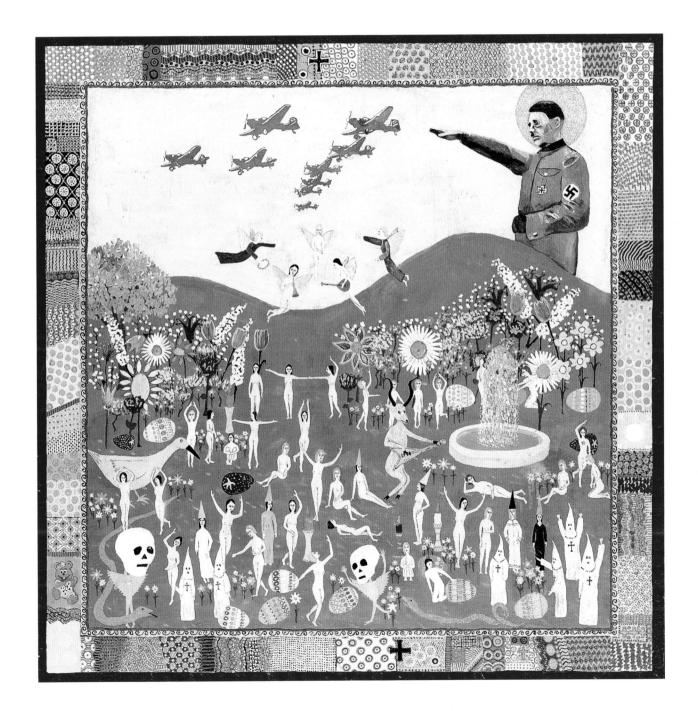

Recent excavations in Latin America have turned up this fascinating image of a pre-Columbian Martian. The figure is made of stone and about one and a half feet hight. It was part of a Mayan Temple destroyed by some cataclysm over a thousand years ago. Apparently the center of a renegade group of Priests, the city was unnoticed till now because it had been totally devastated in almost purposeful way.

The DEVIL is a MARTIAN!

The familiar figure of the devil we know from antiquity is really a martian!

The image of god, a kindly old man with a long white beard and robe is an actual venusian! The martians have tried to fool us out of our pagan pantheistic beliefs into the notian of one god, one devil. In reality there were always many "gods" and many "devils",and numrerous "angels" and "demons" That is, until the martians wiped out the venusians and the "gods" and "angels" with them.

There are still venusians left (we are their interbred descendants!),however when they have tried to tell the truth, they are ridiculed or ignored. In Mexico, when virgins were offered to the sun god they did not die as martian archeoligists have claimed, but bred with the aliens producing the fabled blond natives as offspring. Our own beloved queen Yma is a direct descendent of the venusian rulers of Peru, a true daughter of the gods

Jim Shaw

END IS HERE (BACK COVER, 1978), 2004
MIMEOGRAPH
8 1/2" x 7"

Shag

BBQ, 2004
THREE COLOR ETCHING
10" x 8"

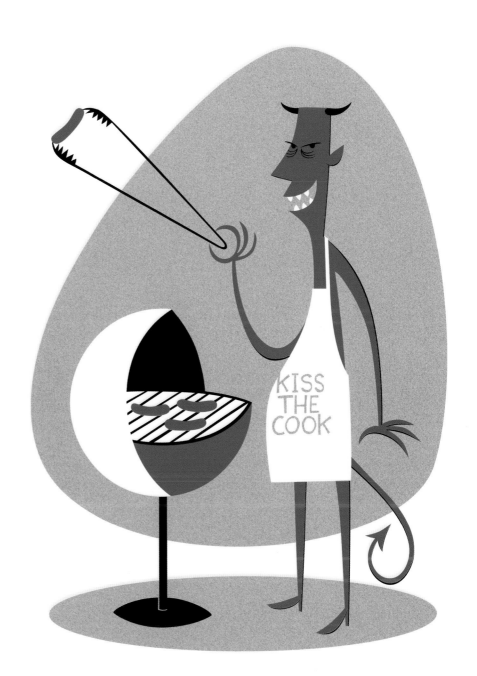

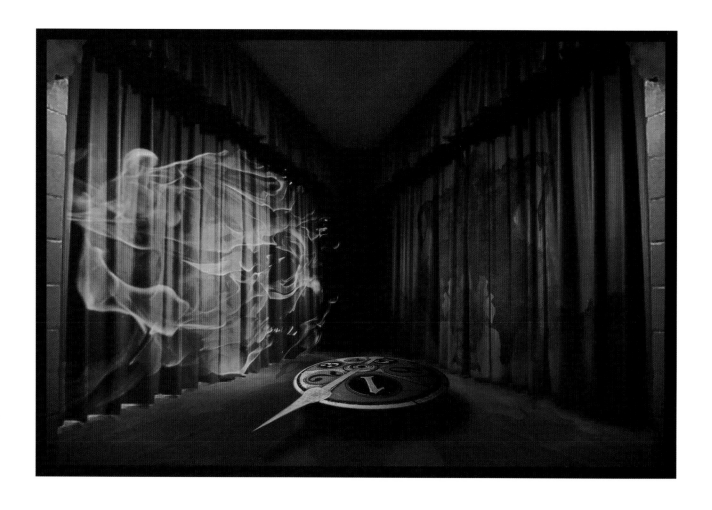

Ilene Segalove

STAGED RAW SHOCK ON FIRE, 2004
Archival pigment digital photograph
21" x 31"

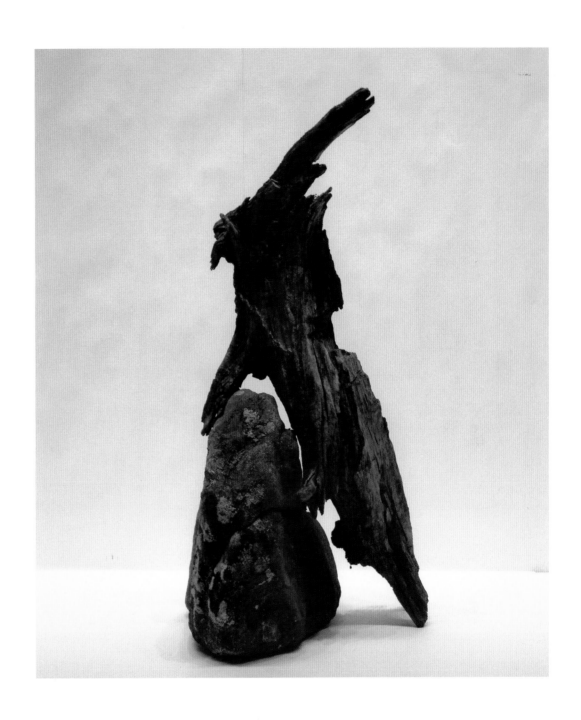

Dustin Schuler

UINTA, 1990
Wood, rock, lichen and oil paint
25 1/2" x 14" x 14"

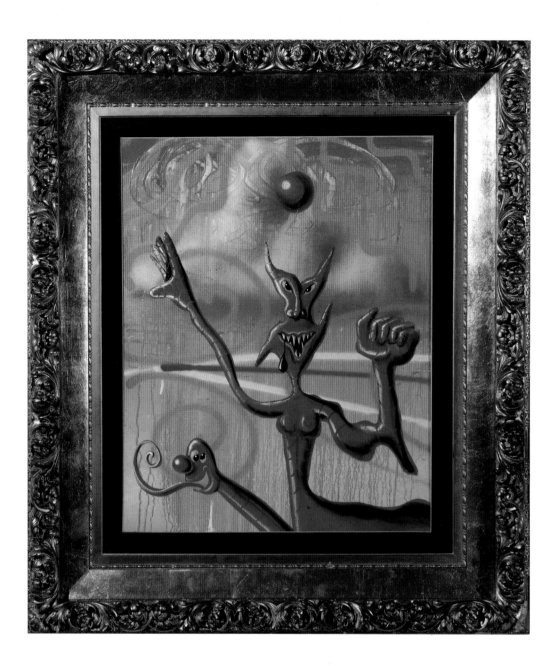

Kenny Scharf

HOT DICKETY DEVIL, 1985
Oil and acrylic on canvas
37 1/2" x 42 1/2"
Collection of Carmen and John Fernandez

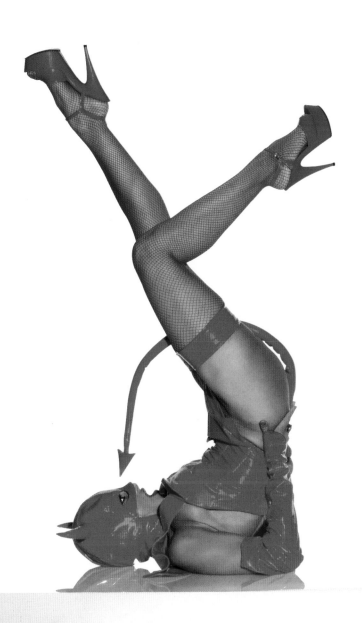

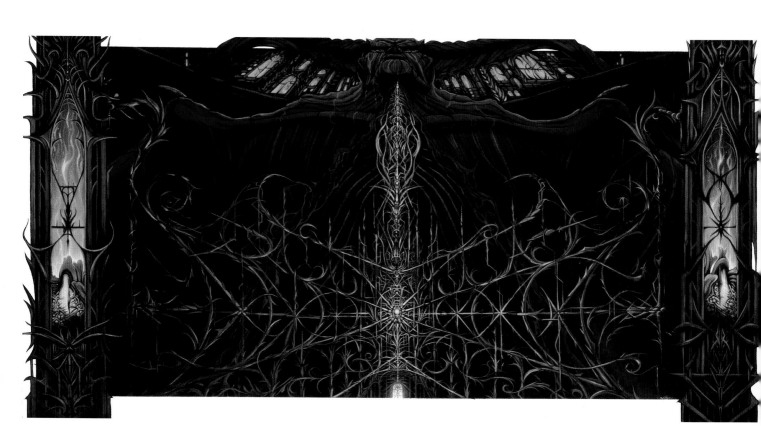

SABER

HELLSGATE, 2002
ACRYLIC ON CANVAS
2' x 3 1/2'

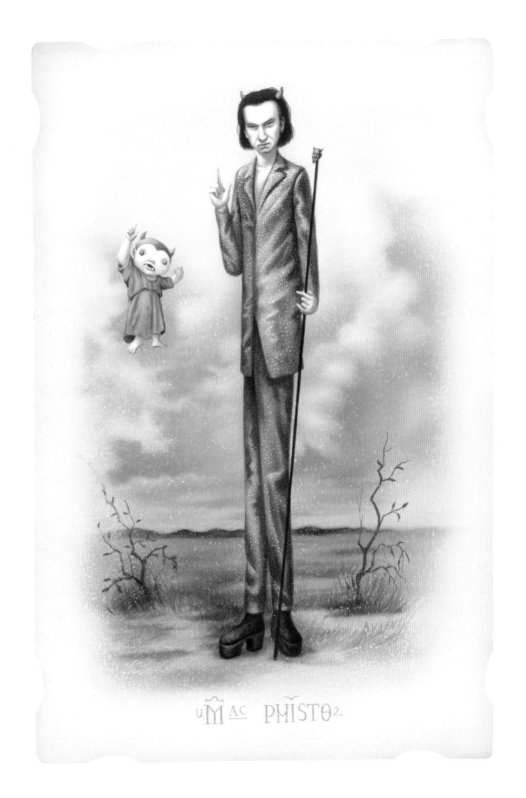

uM̃ac PHĨSTO².

Mark Ryden

MAC PHISTO, 1993
ACRYLIC ON BOARD
16" x 10 1/2"

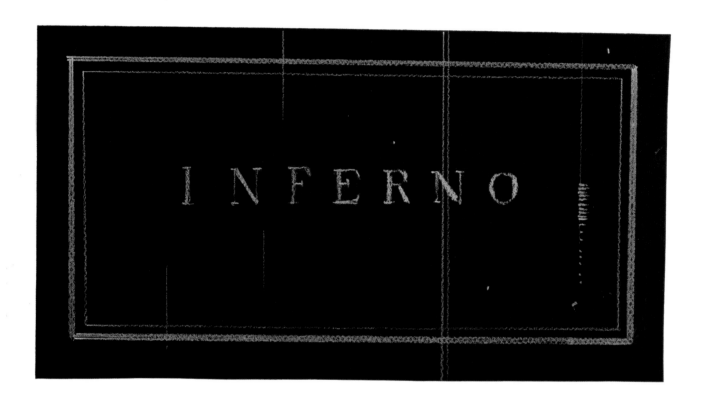

Ed Ruscha

INFERNO STUDY, 1991
Pastel on black paper
6 1/4" x 11 5/8"
Collection of Paul Ruscha
Photo by Paul Ruscha

Erika Rothenberg

WHO WOULD YOU KILL?, 2004
Book, feather pen and glass pen holder
12 1/2" x 13" x 1"
Courtesy of Rosamund Felson Gallery, Los Angeles

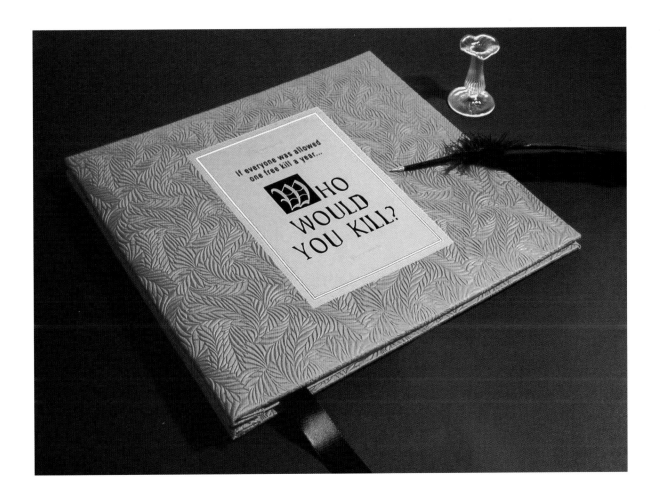

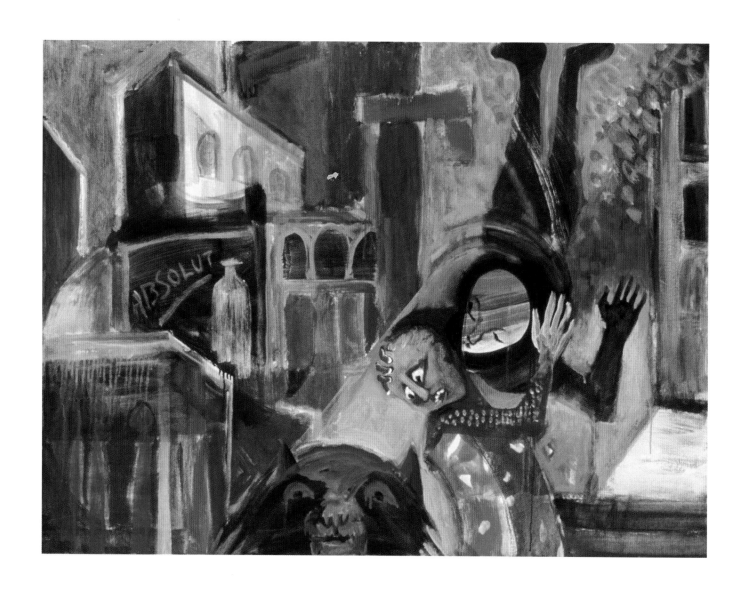

Rachel Rosenthal

ANNUNCIATION, 2002
OIL ON CANVAS
30" x 40"

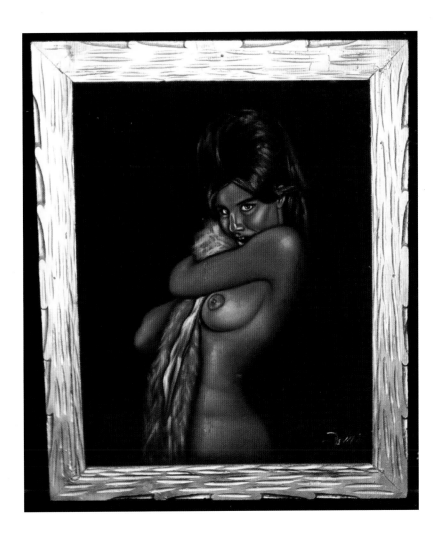

Boyd Rice

LUST. PRIDE. DECEIT. TEMPTATION.
(WOMAN, THY NAME IS SATAN), 2004
FOUND BLACK VELVET PAINTING.
36" x 24"

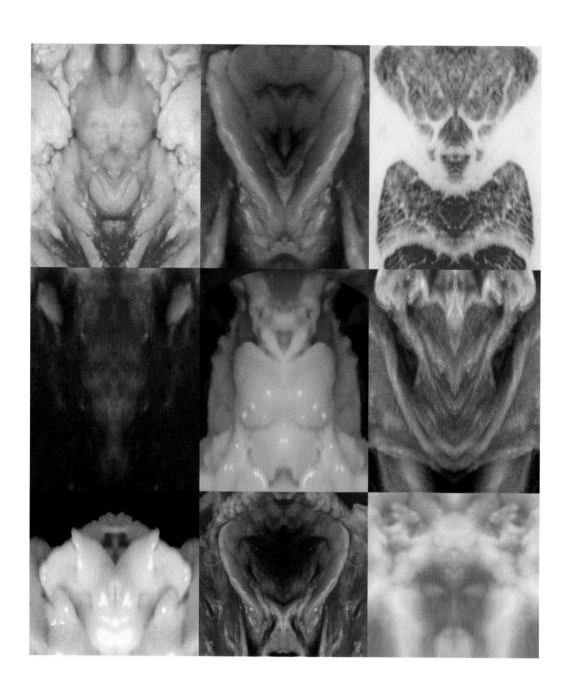

Victoria Reynolds

SATAN IN THE FLESH (BAD MEAT), 2004
Digital print
14" x 11"

Roland Reiss

DEVILS HIDE IN CORNERS, 2004
ACRYLIC ON PANEL
36" x 48"

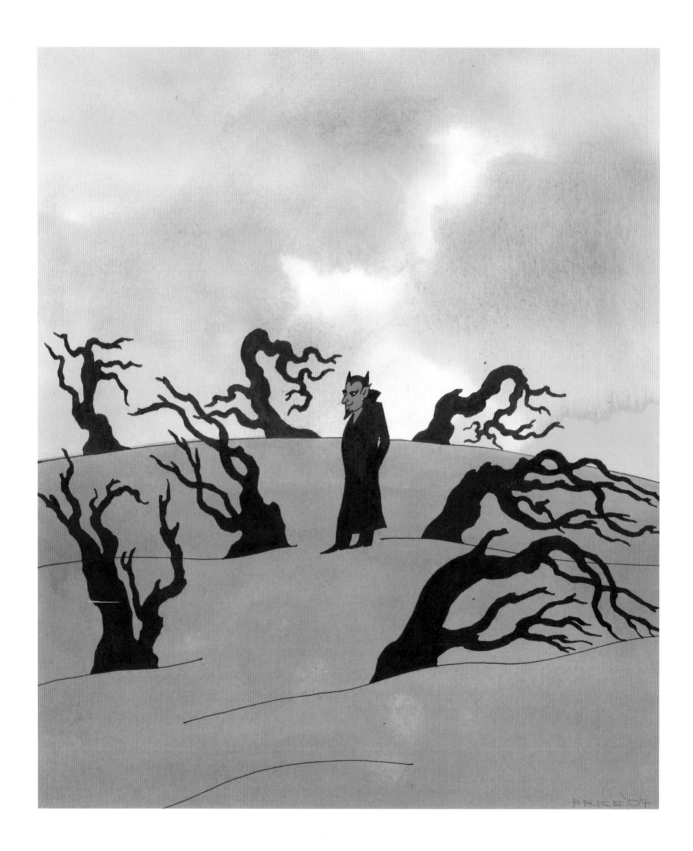

Kenny Price

"NOW GOD IS RESPONSIBLE FOR GOOD, AND HUMANS ARE RESPONSIBLE
FOR EVIL, SO SATAN IS ON VACATION AND ENJOYING A STROLL THROUGH HIS
FOREST OF MINIATURE WAR TREES," 2004
ACRYLIC AND INK ON PAPER
11" X 9"

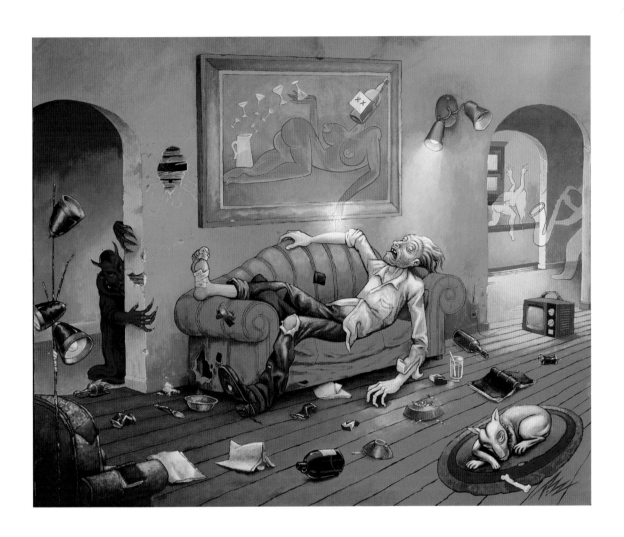

The Pizz

DT'S..., 1999
OIL ON CANVAS
36" X 42"
COLLECTION OF SHAWN WARCOT

Raymond Pettibon

UNTITLED, N.D.
INK ON PAPER
10" x 9"
COLLECTION OF GARY PRESSMAN

Manuel Pardo

ACCESSORIZE, 2004
PENCIL ON PAPER
20 1/2" x 16 1/2"

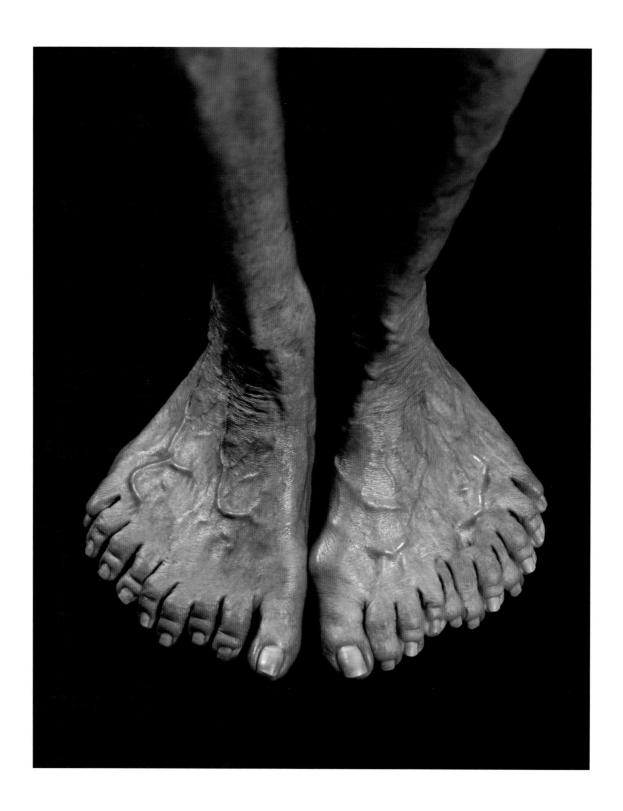

Daida Ospina

UNTITLED (FEET), 2003
Archival inkjet print
15" x 12"
Courtesy of acuna-hansen gallery, Los Angeles

Enjgong Doh

HEAD OF A WOMAN, 2003
OIL ON BOARD
12 3/4" x 16 1/8"
COURTESY OF HUNSAKER/SCHLESINGER FINE ART GALLERY

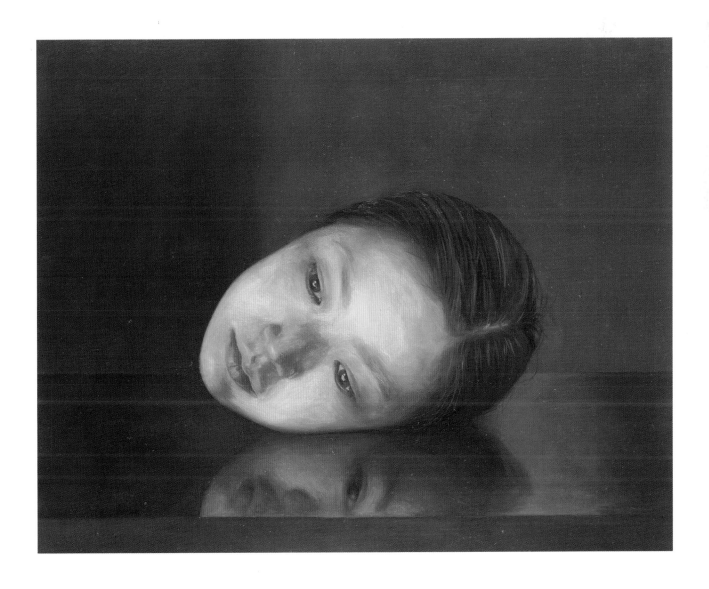

Martin Mull

THE LESSER OF TWO EVILS, 2004
Oil on paper
19 1/2" x 19 1/2"
Courtesy of Patricia Faure Gallery

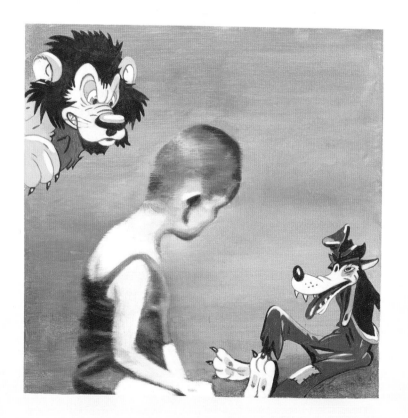

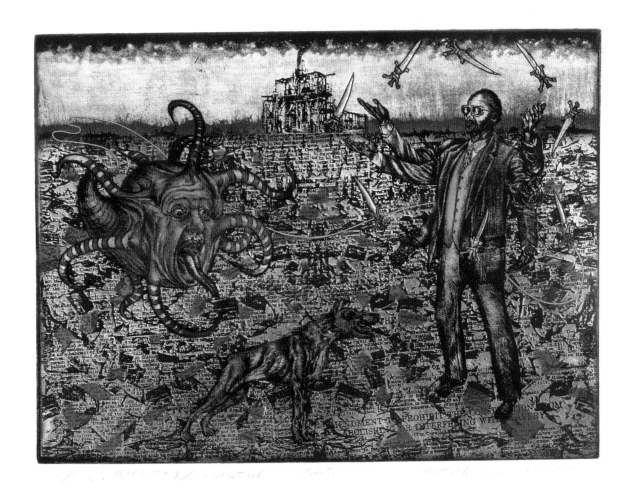

Patrick Merrill

MR. S GOES TO WASHINGTON, 2004
Four plate etching
9" x 12"

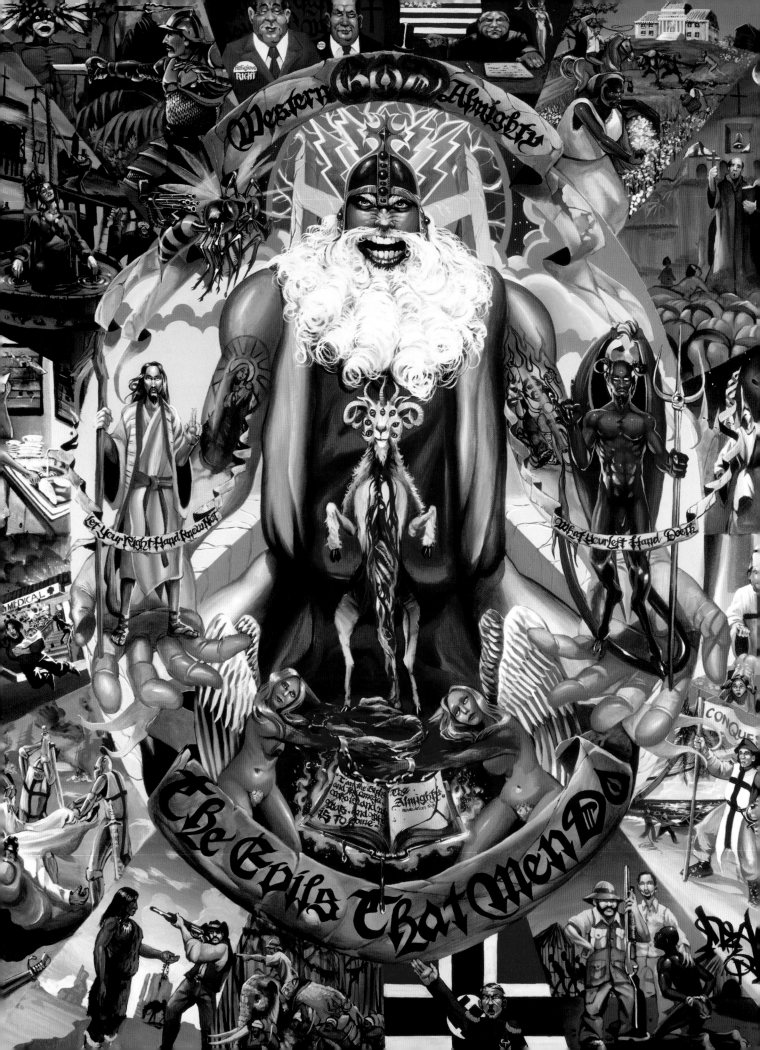

Mear

THE WESTERN GOD ALMIGHTY, 2003
Acrylic on canvas
60" x 48"

Dean McNeil

THE BUDDHA FACTORY, 2004
Cibachrome Print
20" x 20"

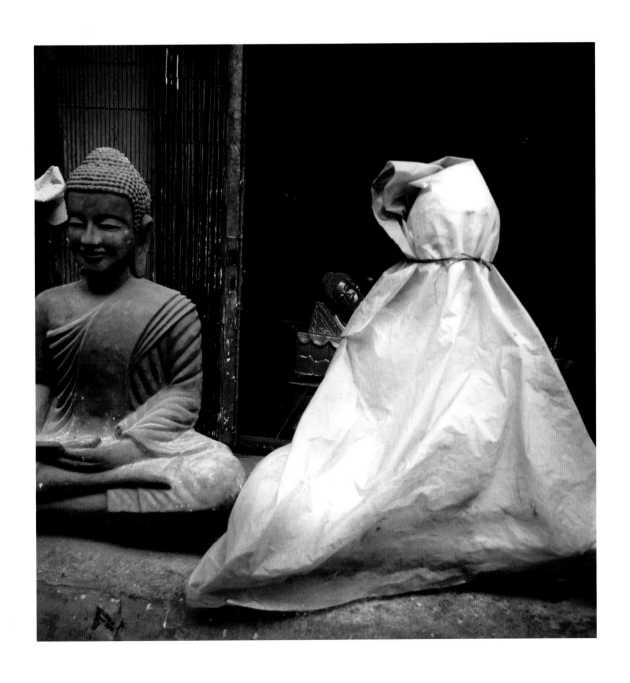

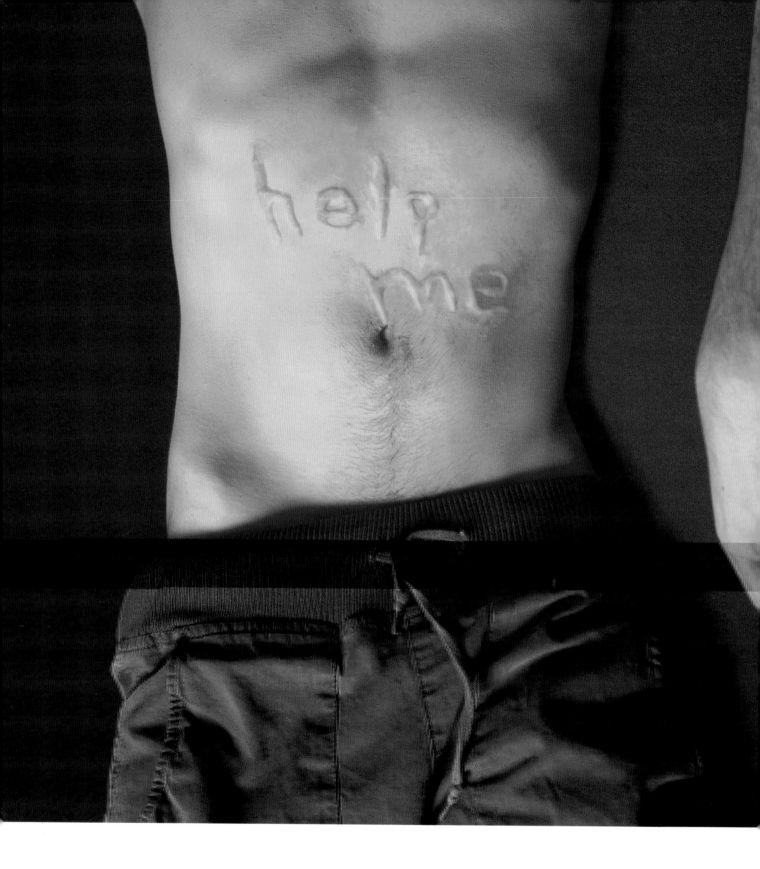

Ryan McNamara

HELP ME, 2004

When I watched "The Exorcist" recently, I was particularly struck by the scene where fully-possessed Regan MacNeil had the words "help me" appear on her abdomen. I imagined a Lil' Ryan to do the same. After months of training, he started making marks, which eventually developed into letters. This past week he made his first sentence and coincidentally he chose the same statement Lil' Regan chose. I wanted to show off his work, so I booked a stripping gig at The Slide.

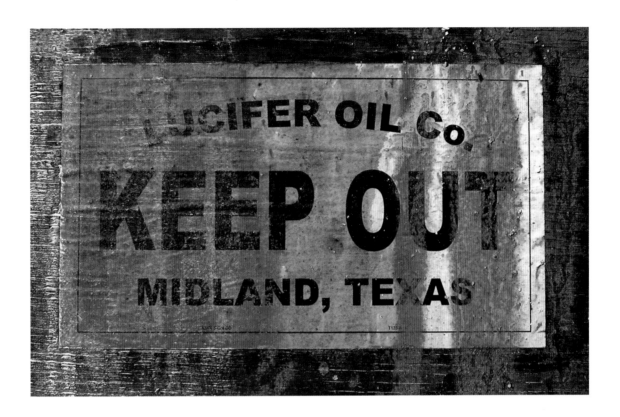

Michael C. McMillen

KEEP OUT, 2004
DIGITAL PHOTOGRAPH
VARIABLE DIMENSIONS

Michael P. McManus

AMERICAN PRAYER SERIES: LILITH, 2004
Collage
7" x 5"

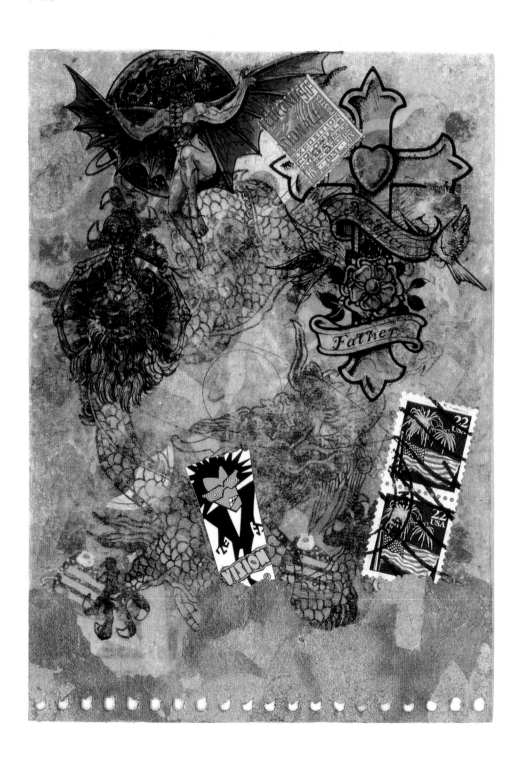

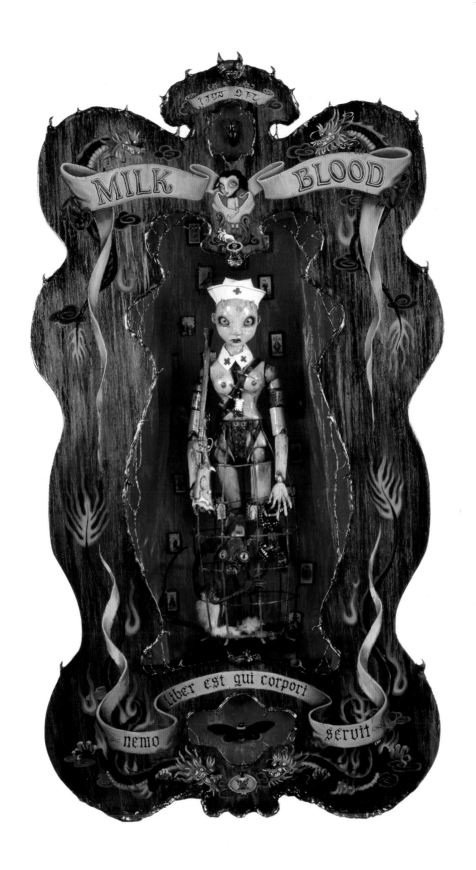

Elizabeth McGrath

MILK BLOOD, 2002
Mixed media
72" x 43"
Collection of Jamie and Angie Sciarappa

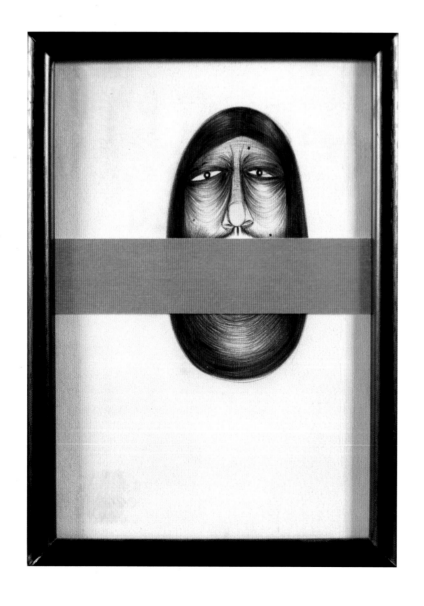

BARRY McGEE

UNTITLED, N.D.
MIXED MEDIA
COLLECTION OF KEVIN ANCELL
PHOTO BY M.O. QUINN

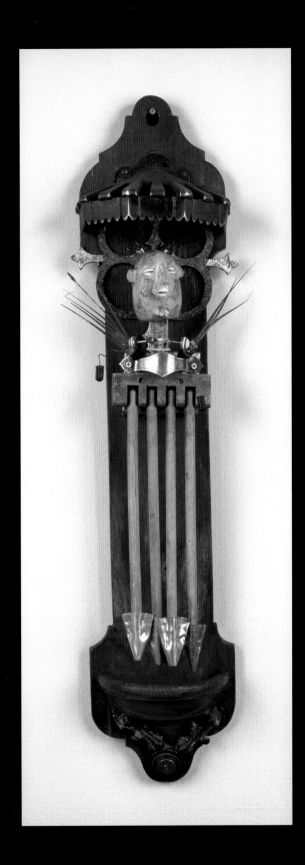

Janice Lowry

SATAN'S REST, 2004
Mixed media
31" x 7" x 5"
Photo by M.O. Quinn

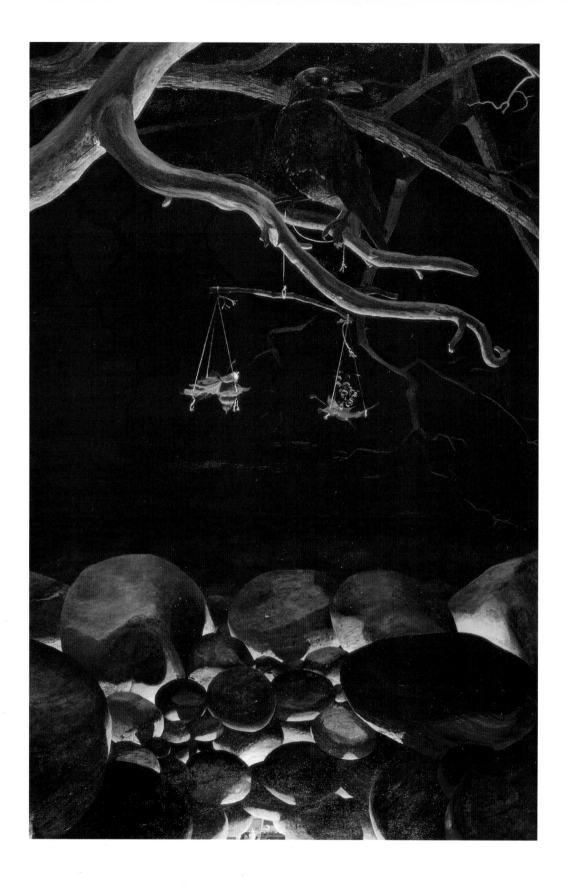

James Lorigan

JUDGE , 2004
Acrylic on canvas
72" x 48"
Collection of William J. Folan
Photo by M.O. Quinn

Bad Otis Link

HELL BELLY, 2004
Mixed media
12" x 9"

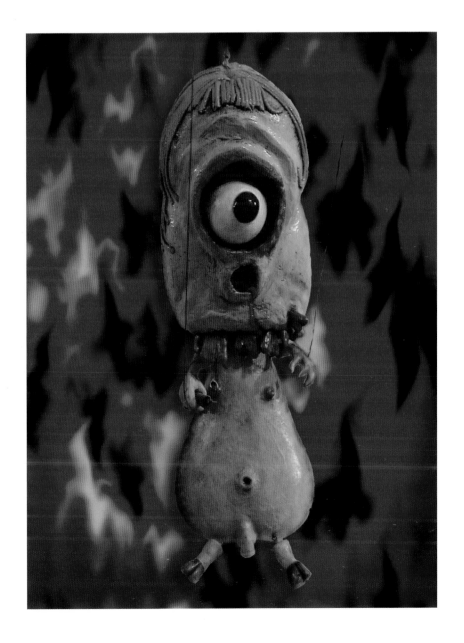

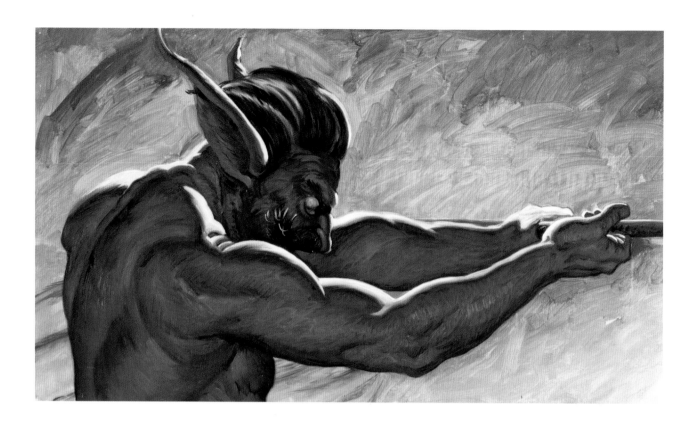

Don Lagerberg

CHARON EXTREME, 1996
Oil on wood
8' x 13'
Photo by M.O. Quinn

Paul Laffoley

PICKMAN'S MEPHITIC MODELS, 2004
Mixed media
72" x 60" x 4"
Courtesy of Paul Laffoley and The Kent Gallery, New York

KARLA GUTKELED: JANITRIX

WELCOME TO HELL

HERE WE ARE ALL ALONE TOGETHER

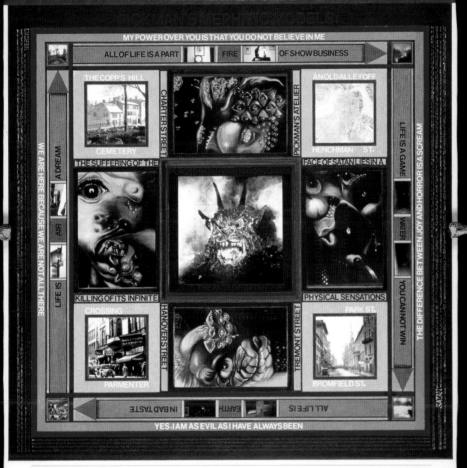

MY POWER OVER YOU IS THAT YOU DO NOT BELIEVE IN ME

ALL OF LIFE IS A PART FIRE OF SHOW BUSINESS

THE COPP'S HILL AN OLD ALLEY OF F
CEMETERY HENCHMAN ST.

THE SUFFERING OF THE FACE OF SATAN LIES IN A

KILLING OF ITS INFINITE PHYSICAL SENSATIONS

CROSSING PARK ST.
PARMENTER TREMONT STREET BROMFIELD ST.

ALL LIFE IS EARTH IN BAD TASTE

YES, I AM AS EVIL AS I HAVE ALWAYS BEEN

Diana Kunce

I SEE SATAN AND HE IS EVERYWHERE, 2004
SX-70 Polaroid
48" x 42"

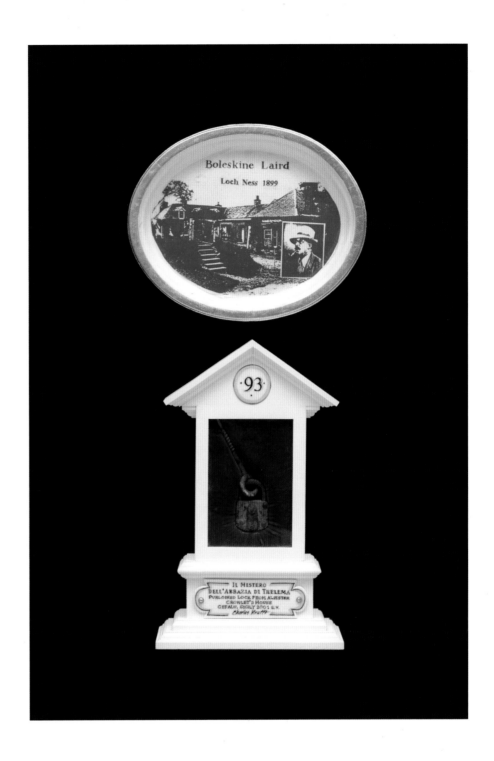

Charles Krafft (w/Warner Lindholm)

IL MISTERO dell' ABBAZIA di THELEMA, 2004
Purloined padlock from Aleister Crowley's house in
Cefalu, Sicily and paper picnic plate.
Wood, glass, velvet, lock, ceramics and gilded Chinet®
paper plate.
Reliquary 15" x 9 3/4" x 4 1/2"
Paper plate 10" x 12 1/2"

Frank Kozik

TOODLES, 2004
Acrylic and oil on canvas
48" x 36"
Courtesy of La Luz de Jesus Gallery

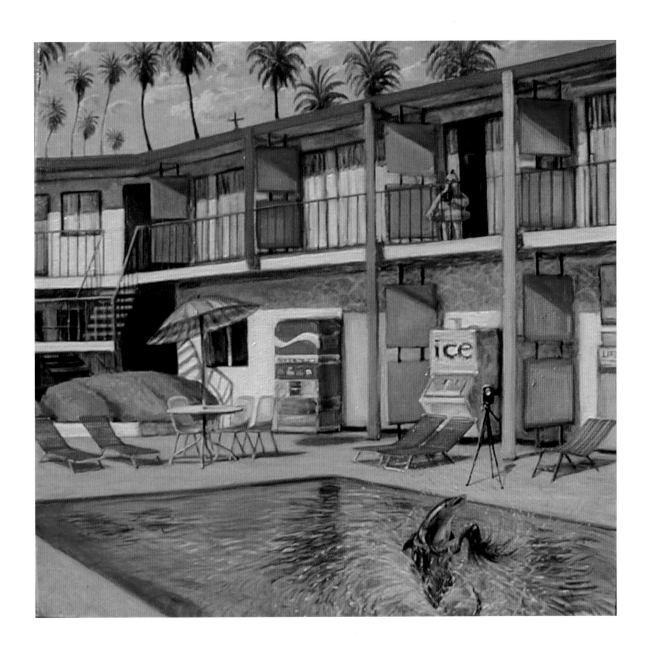

Michael Knowlton

CAPTIVE MERMAID- THE DEVIL'S DOLPHIN DANCE, 2004
Oil on linen
33" x 34"

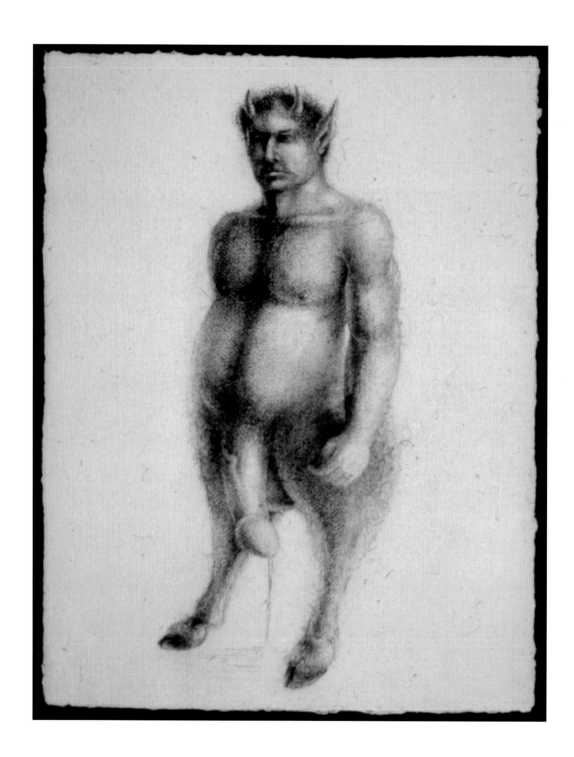

Tom Knechtel

THE SATYR, 1992
PASTEL ON PAPER
26" x 20 1/4"
COLLECTION OF LINDA BURNHAM

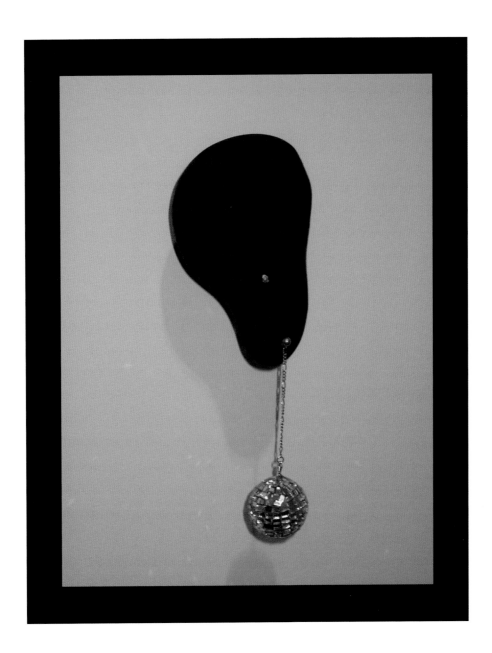

Martin Kersels

BLACK HOLE, 2002
Wood, mirror glass, paint & silver chain
9 1/2" x 5" x 3 1/2"

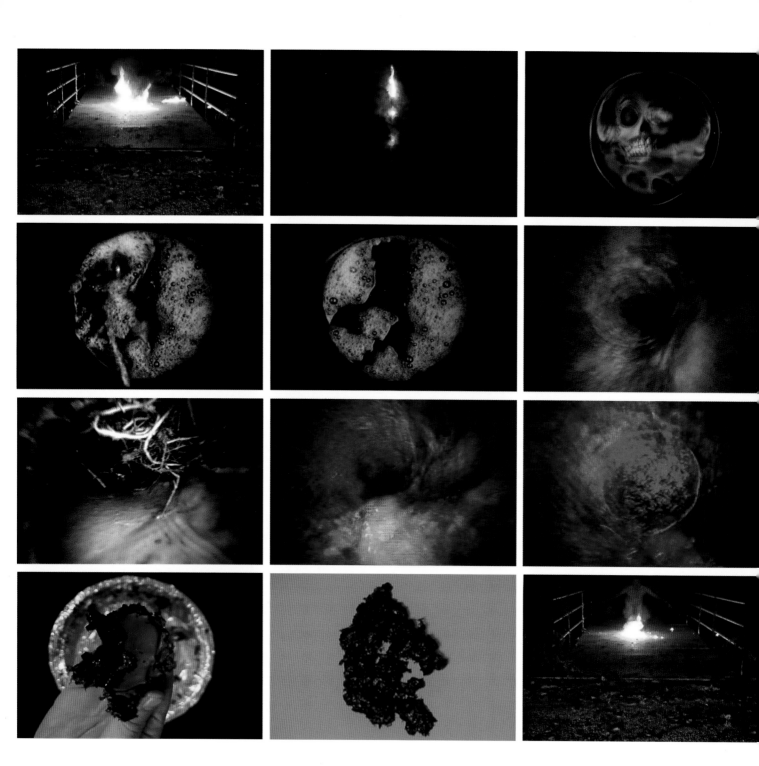

Mike Kelley

BRIDGE VISITOR, 2004
(Legend-Trip)
Single channel video on DVD
17:54 minutes

Seth Kaufman

REACH OUT AND TORCH SOMEONE, 1992
Telephone pole, screws, chain, steel, found materials from
buildings destroyed during the 1992 Los Angeles Riots
38" x 14" x 14"

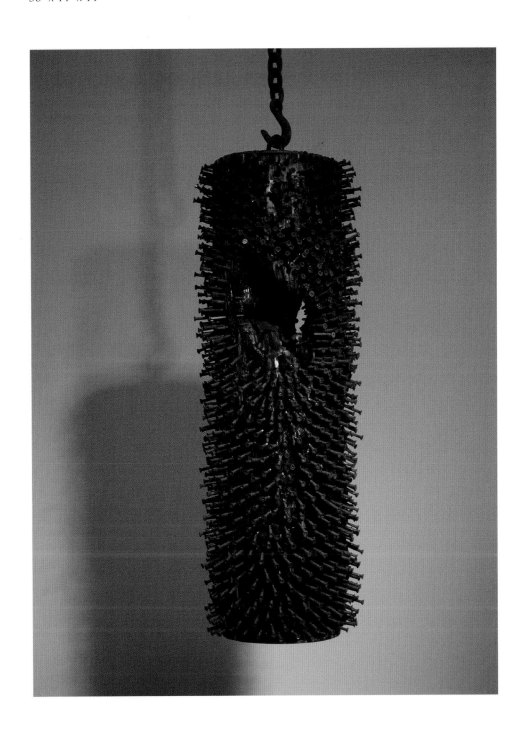

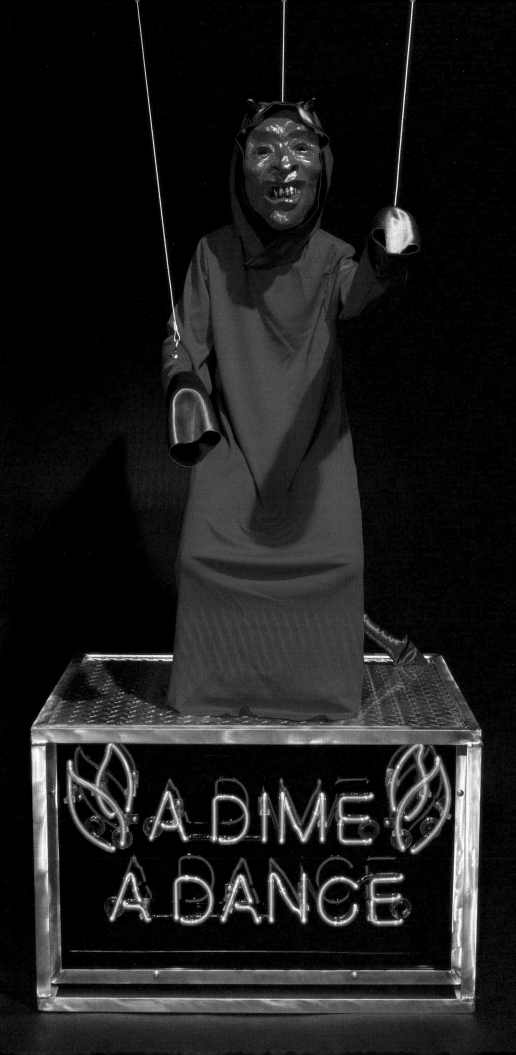

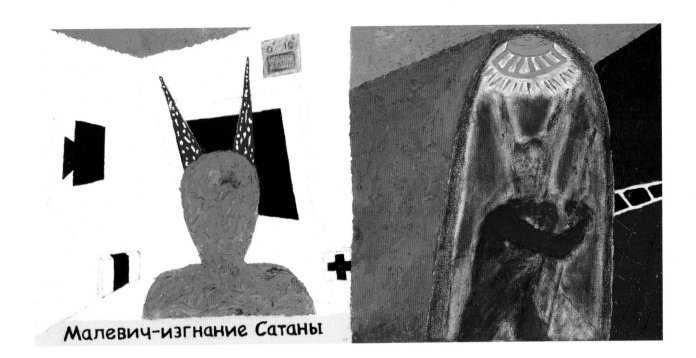

Малевич-изгнание Сатаны

James Hill

MALEVICH – BANISHMENT OF SATAN, 2004
Paint, pencil and chalk
12" x 24" x 3"
Translation by Victor Voronel

Jim Jenkins

A DIME A DANCE, 2004
Mixed media
64" x 31" x 24"
Photo by M.O. Quinn

F. Scott Hess

WEDDING SACRIFICE, 1992
OIL ON CANVAS
16" x 20 1/2"
COLLECTION OF PETER ZOKOSKY

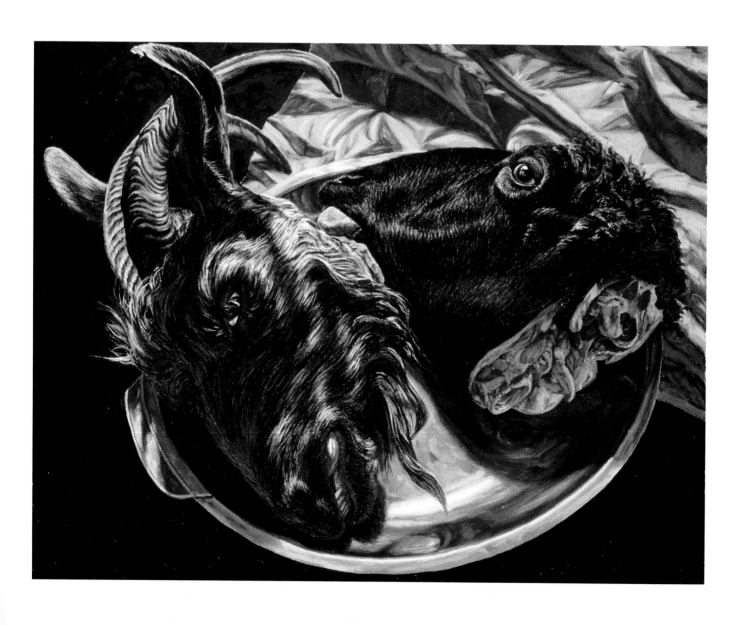

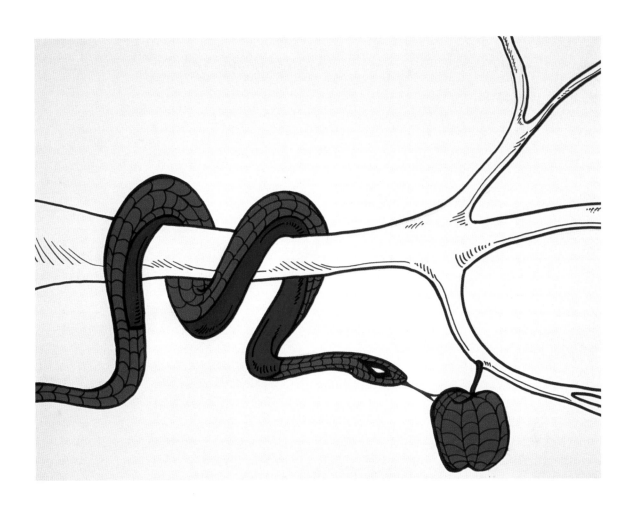

MARK HERSEY

SPIDER-EDEN, 1992
ACRYLIC ON PAPER
22" x 28"

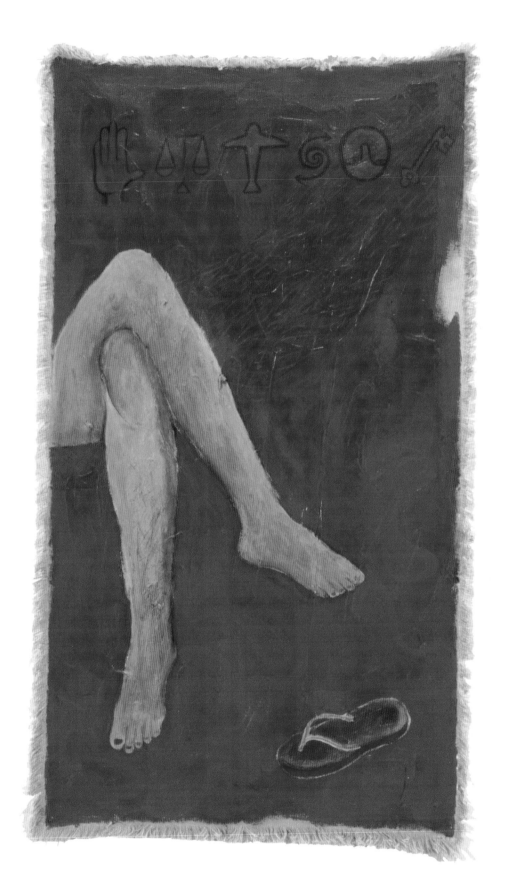

Analda Hernandez

ENIGMA, 2002
ACRYLIC ON LINEN
48" x 27 1/2"

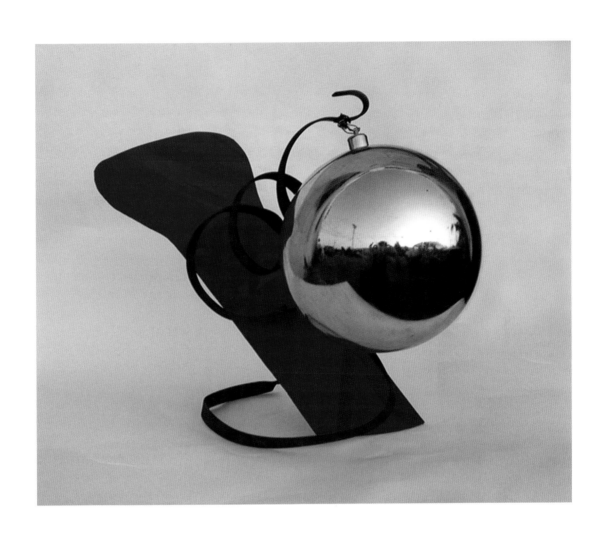

Laurie Hassold

STRANGE ATTRACTOR, 2004
MIXED MEDIA
36" x 52" x 22"

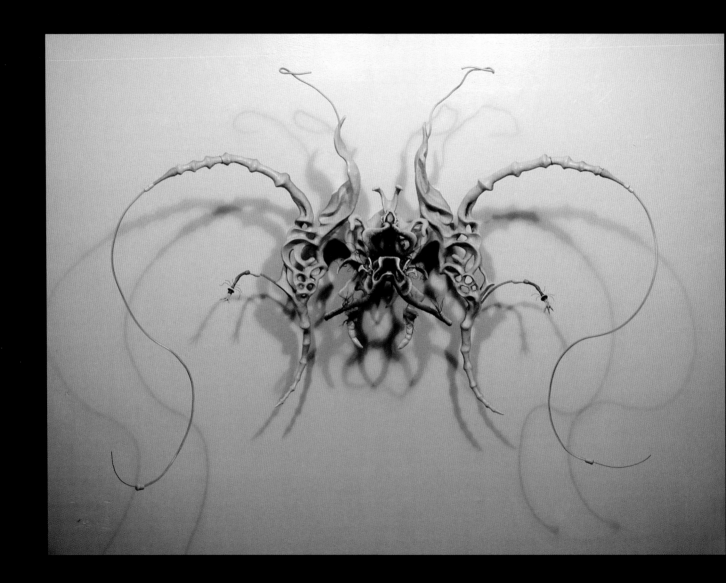

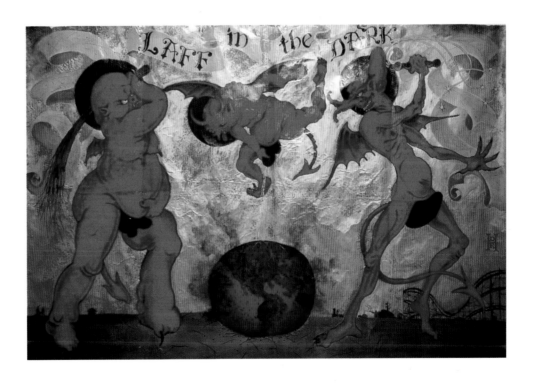

Don Ed Hardy

WORLD BEATERS, 1997
Acrylic, pencil and varnish on handmade Nepalese paper
52" x 76 1/2"
Courtesy of Track 16 Gallery, Santa Monica

Rick Griffin

JESUS SAVES FROM HELL, 1988
Coloured pen and pencil on vellum paper
26" x 22"
Collection of Joe & Cyn Knoernschild

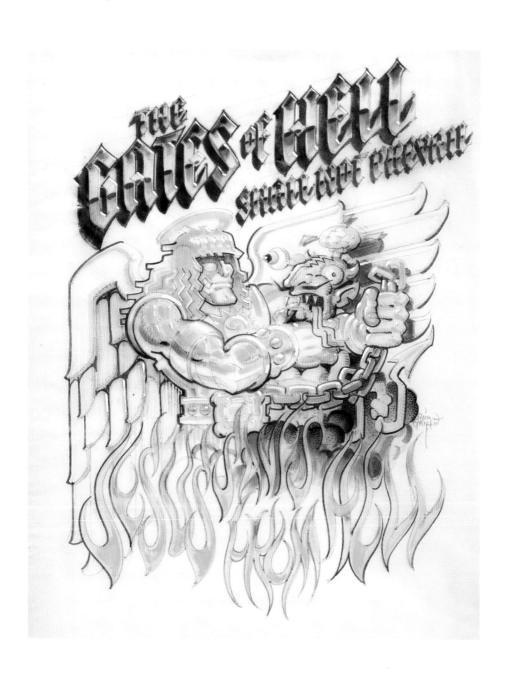

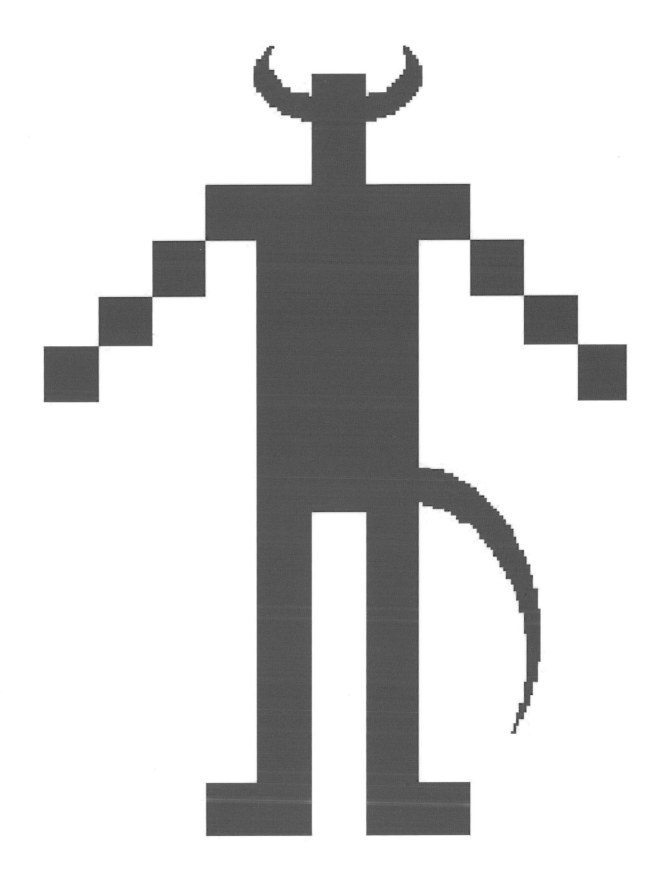

Scott Grieger

DIGITAL DEVIL, 2004
Wall painting
Variable dimensions

ALEX GREY

LOVE FORESTALLING DEATH, 1999
PASTEL, PEN AND GRAPHITE ON BARK PAPER
11 1/2" x 8"

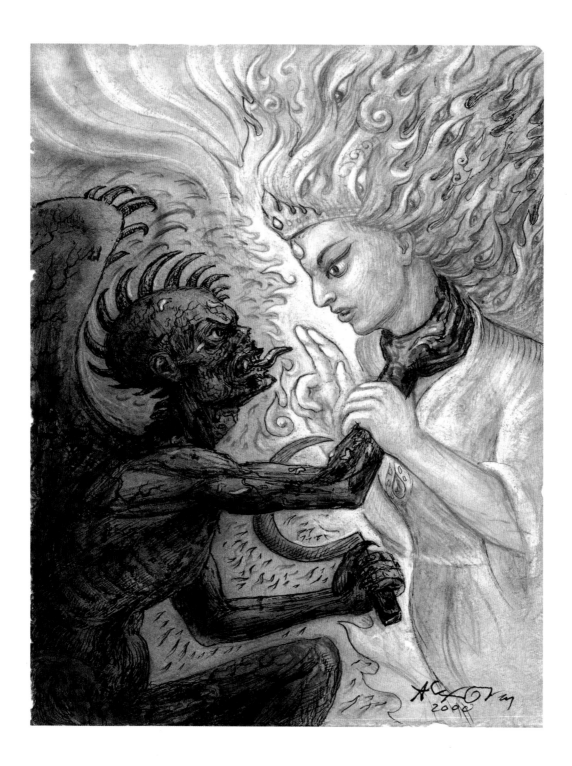

STUART GOW

SANTA #11, 2003
BLACK AND WHITE PHOTOGRAPH
33" x 25"

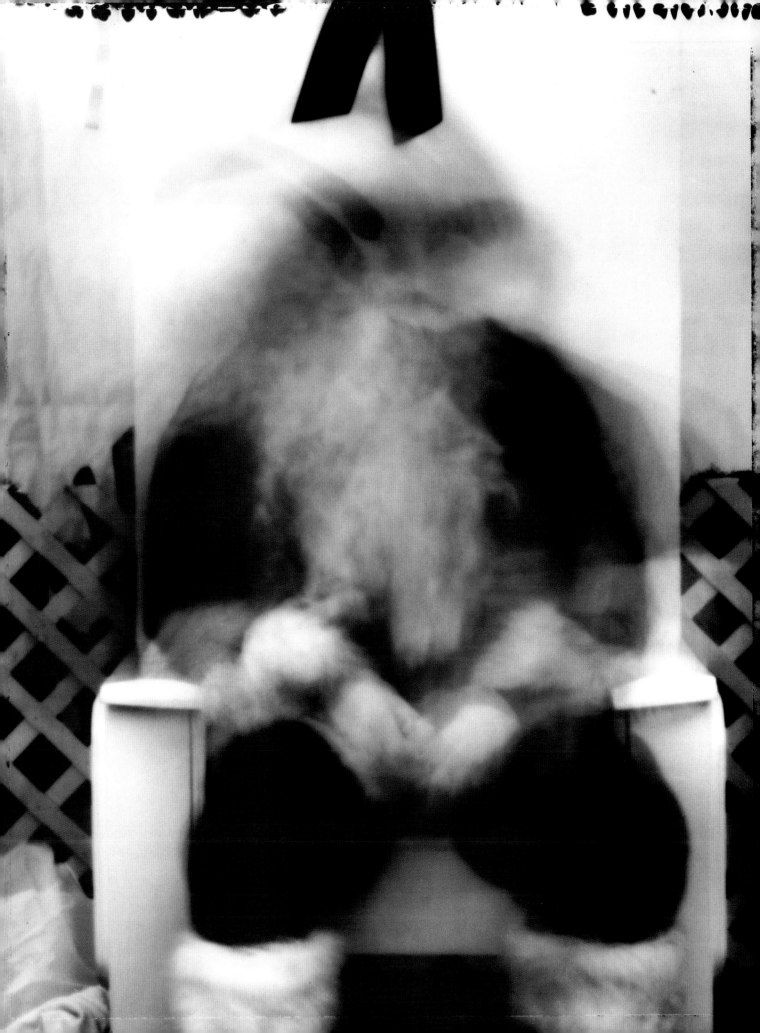

Mat Gleason

DARK ANGEL, 2004
Digital print
21" x 30"

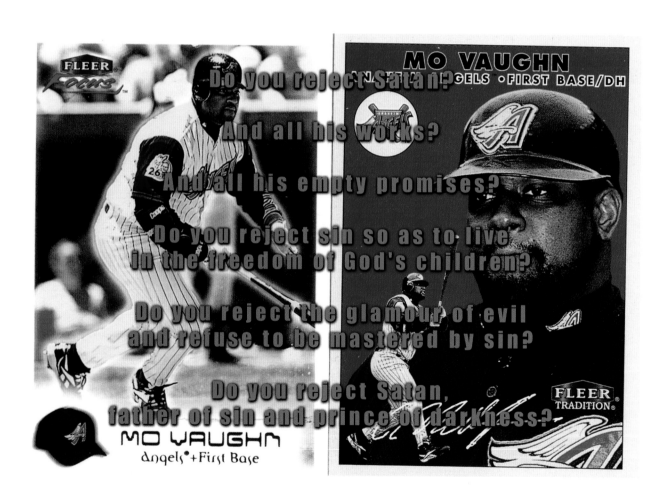

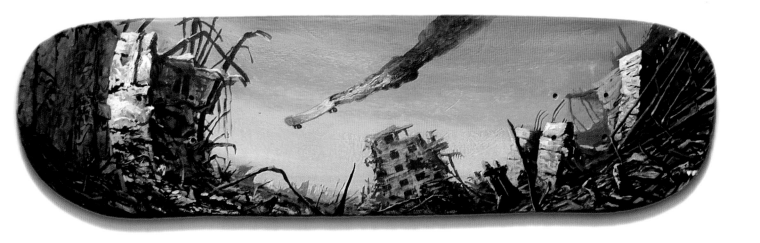

Jeff Gillette

FROM THE SERIES THE DEATH OF SURF CULTURE, 2004
ACRYLIC ON BOARD
8" x 31" x 3"

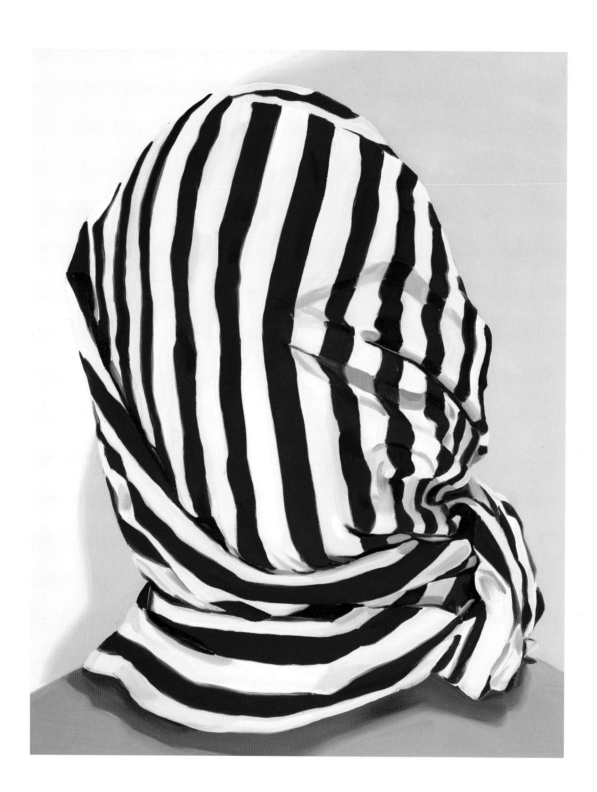

Gregg Gibbs

SELF PORTRAIT (STRIPES), 2001
OIL ON WOOD PANEL
20"x 16"

John Geary

DEVIL SIGHTING
GOLDEN GATE BRIDGE, 1994
Performance video capture
Variable dimension
© 1994, John Geary

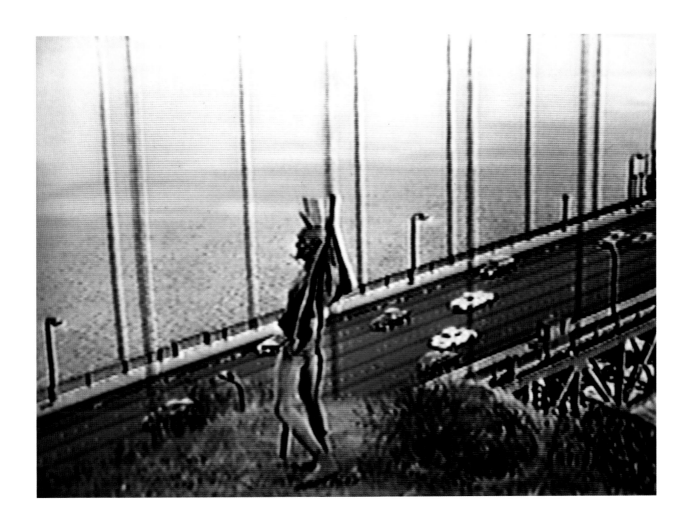

Bia Gayotto

SEEING SATAN, 2004
Two books
10 1/4" x 8 1/4" each book

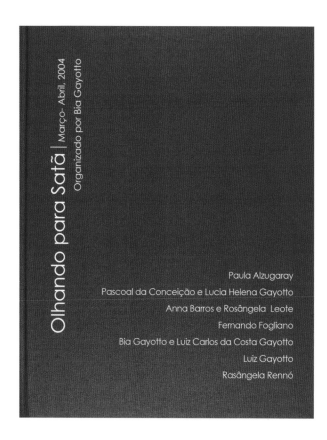

Olhando para Satã | Março- Abril, 2004
Organizado por Bia Gayotto

Paula Alzugaray
Pascoal da Conceição e Lucia Helena Gayotto
Anna Barros e Rosângela Leote
Fernando Fogliano
Bia Gayotto e Luiz Carlos da Costa Gayotto
Luiz Gayotto
Rasângela Rennó

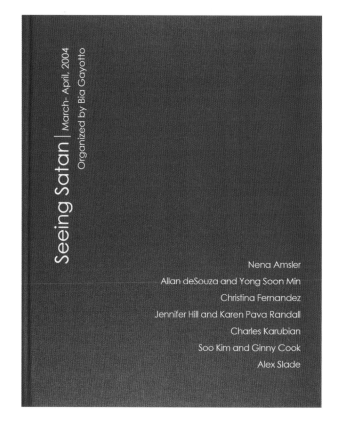

Seeing Satan | March- April, 2004
Organized by Bia Gayotto

Nena Amsler
Allan deSouza and Yong Soon Min
Christina Fernandez
Jennifer Hill and Karen Pava Randall
Charles Karubian
Soo Kim and Ginny Cook
Alex Slade

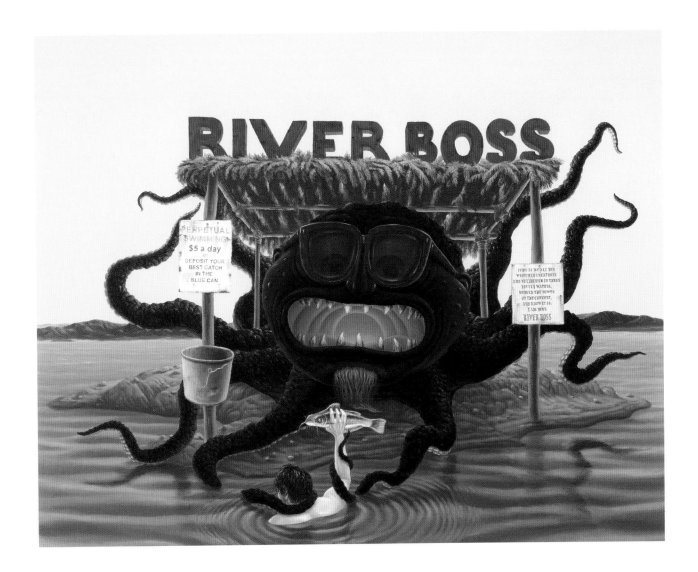

Steve Galloway

RIVER BOSS: THE DEVIL'S BEACH, 2004
Oil on canvas
24" x 30"

Quote: "Five bucks." – the Devil, 2003.

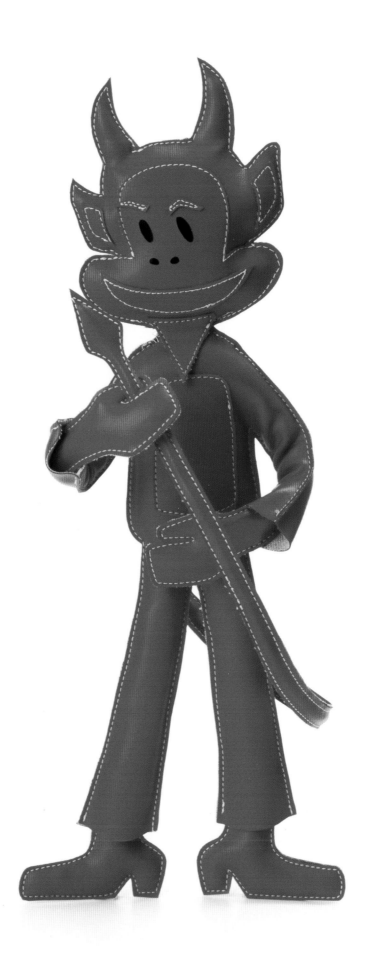

Paul Frank

RED DEVIL JULIUS, 2004
COMMERCIAL GRADE PVC
18 3/4" x 7 1/2"

Llyn Foulkes

OLD GLORY, 2003
Mixed media
51" x 44"
Collection of Elinor and Rubin Turner

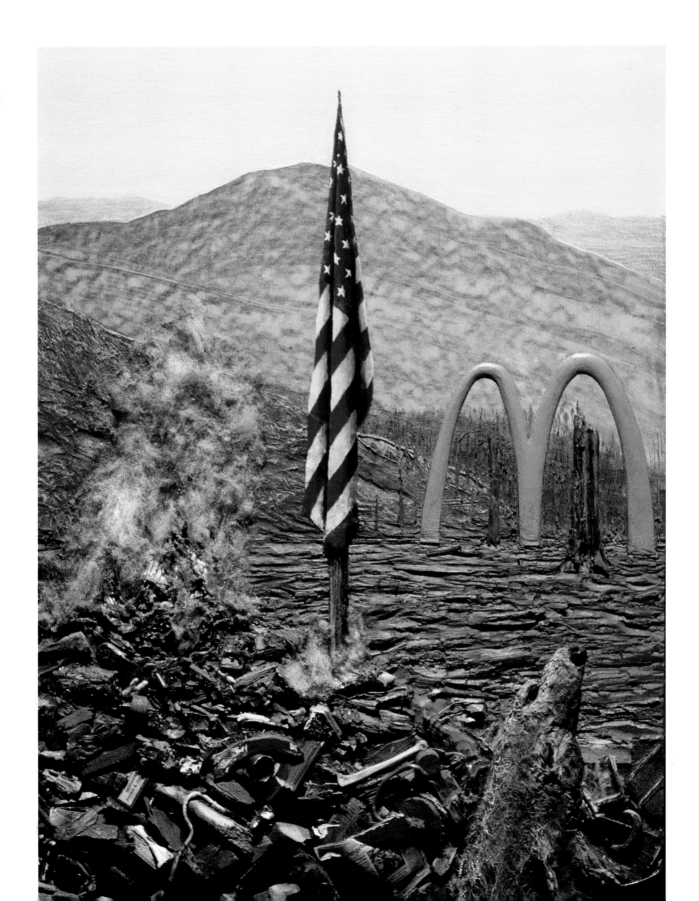

Enzia Farrell

TIKI PARTY, 2001
Oil on wood panel
16"x 12"
Collection of Greg and Kristin Escalante

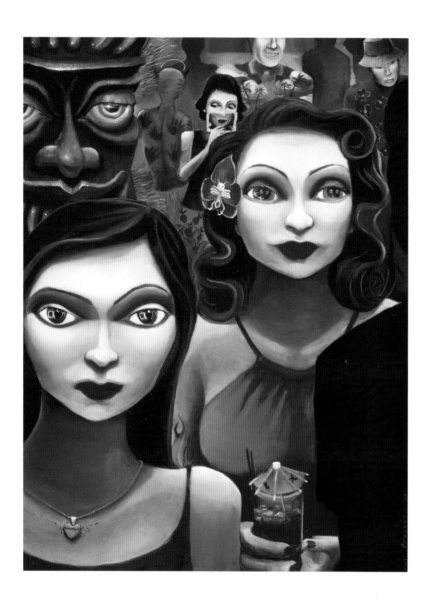

Extremo

I SCREAM, YOU SCREAM, WE ALL SCREAM, 2004
Createx on board
66" x 48"

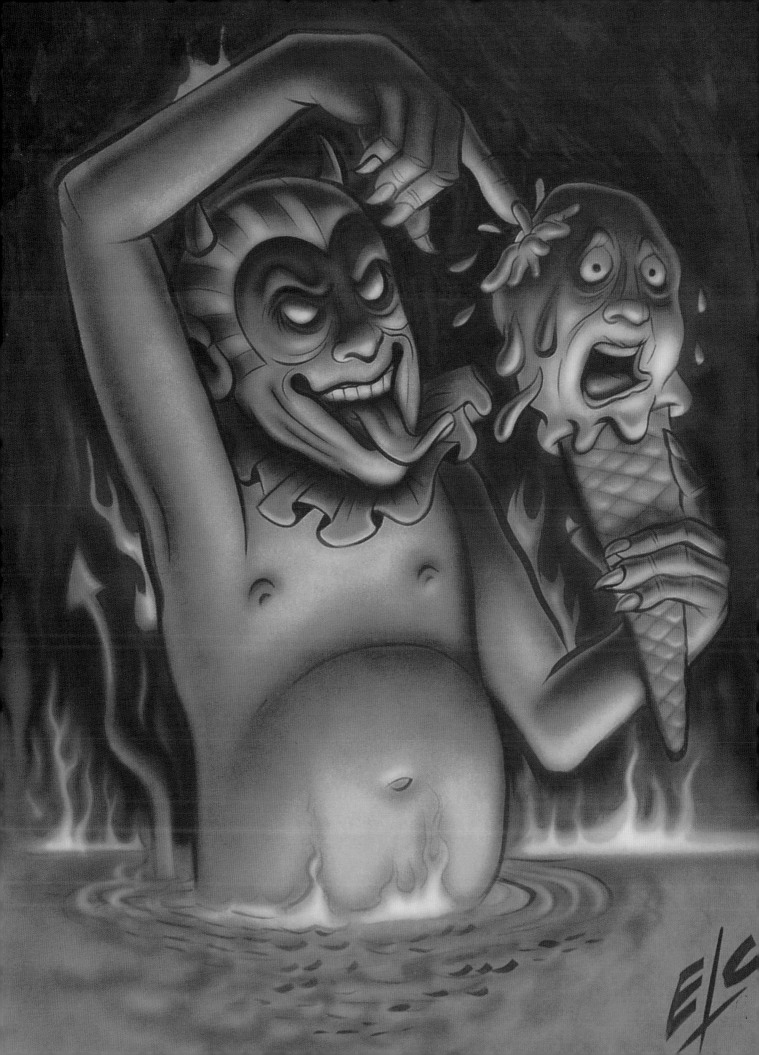

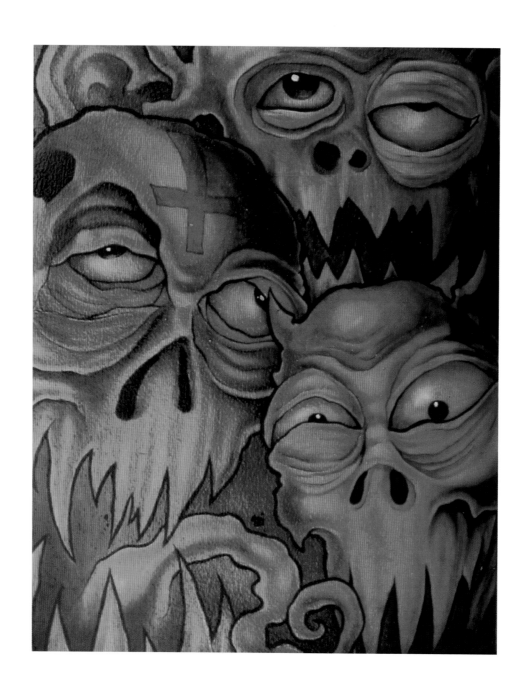

Jason Dugan

LINE STARTS HERE, 2004
OIL ON PANEL
10" x 8"

Einar & Jamex de la Torre

EL ASTRONAUTA, 2003
Mixed media with blown glass
46" x 23" x 8"
Collection of Cheech Marin

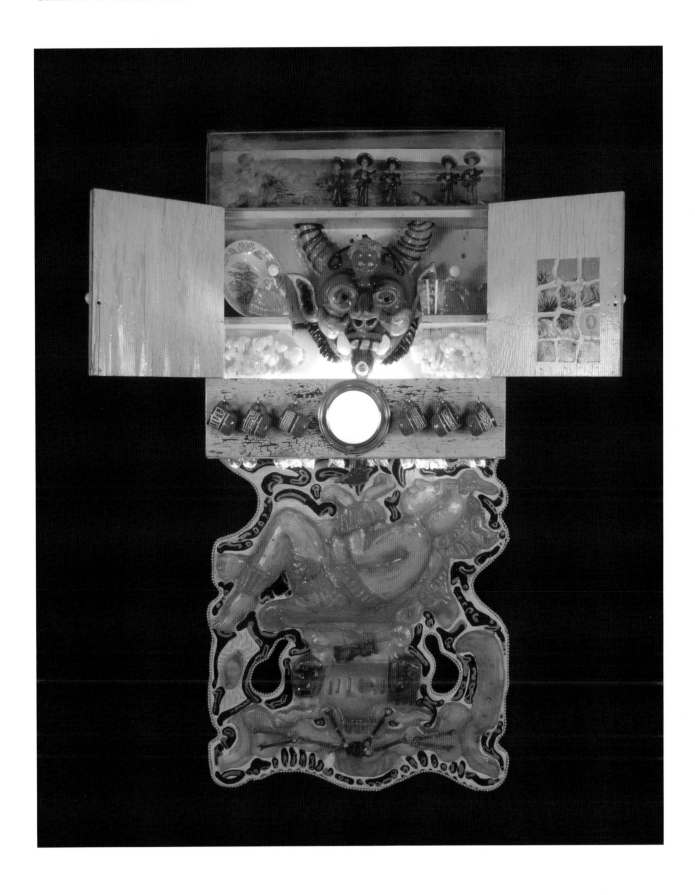

HAT TRICK

Tony DeLap

HAT TRICK, 1993
Watercolor and graphite on paper
15 1/4" x 11"

Mitchell DeJarnett

UNTITLED, 2004
LIGHTJET PRINT
16" x 10"

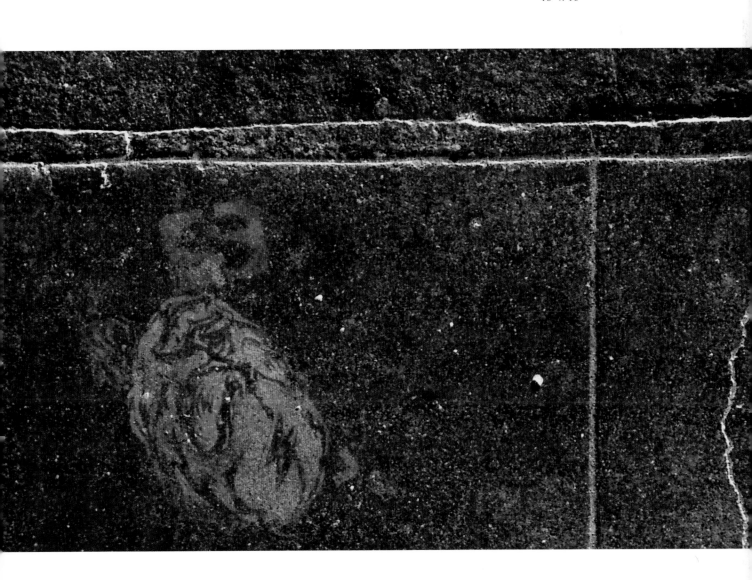

Robert Crumb

GO AND FUCK THYSELF, 1985
Ink on paper
5" x 3 1/2"
Glenn Bray Collection

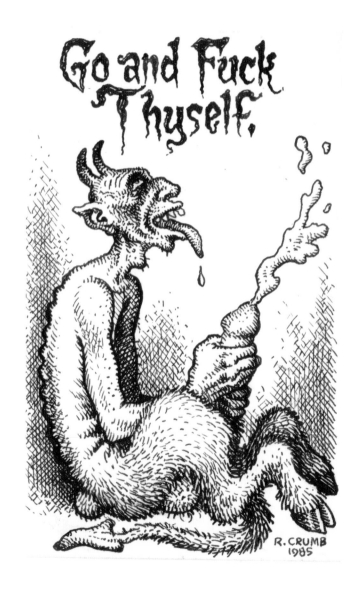

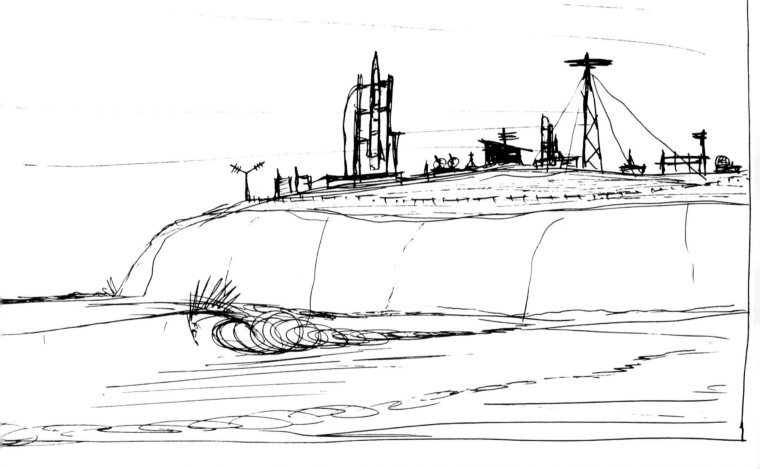

THE LAUNCH TOWERS STOOD LIKE CIPHERS
OF SOME POST INDUSTRIAL NIRVANA
WE WILL BEGIN BOMBING IN FIVE MINUTES

Russell Crotty

UNTITLED, 1992
44 PAGE LINEN COVER BOOK,
12 1/2"x 15" CLOSED

Sarah Cromarty

THE WORLD, THE FLESH, AND THE DEVIL, 2004
Cardboard, wood, glue, varnish, and ink
26" x 28"

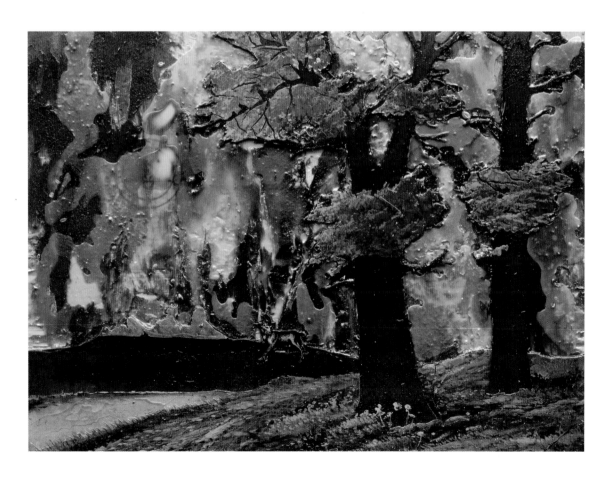

ROSEMARY COUEY

O'ER LADIE'S LIPS, WHO STRAIGHT ON KISSES DREAMS, 1998
WOOD ENGRAVING ON PAPER
14" x 10"

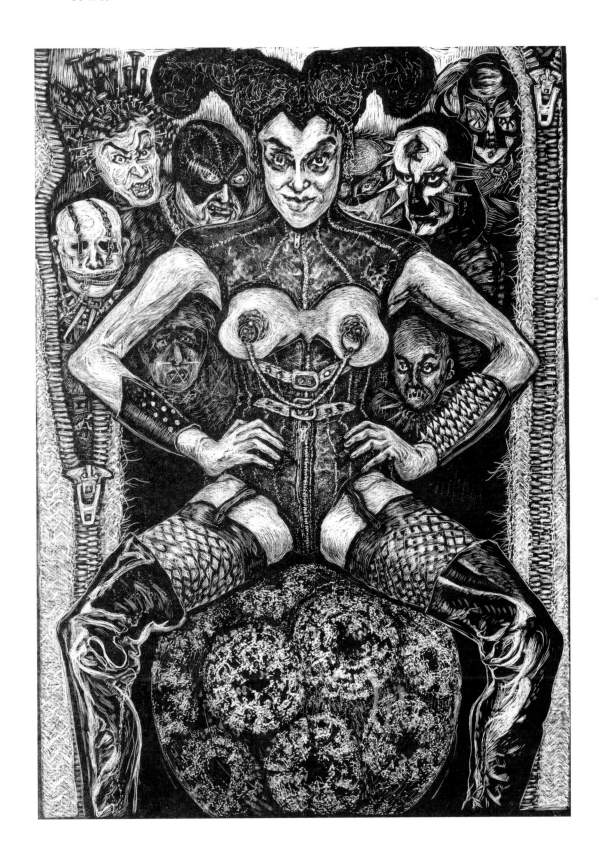

Coop

CHURCH OF SATAN RECRUITMENT POSTER (96-07), c. 1996.
Silkscreen
35" x 22 1/2"
Two editions, one with silver metallic and one with gold metallic
ink for the lettering, 666 prints per edition

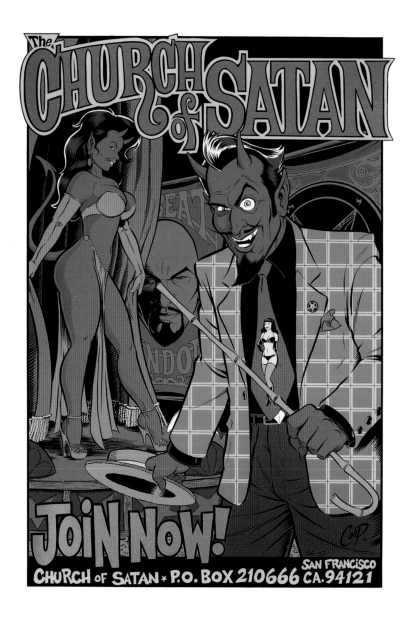

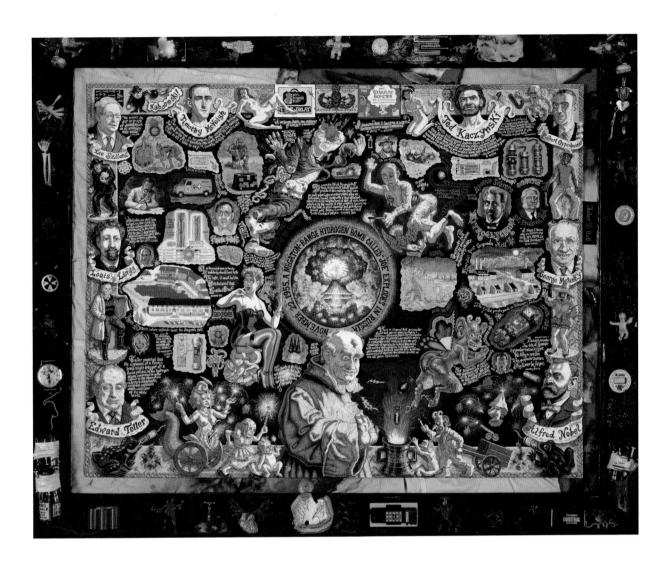

Joe Coleman

BIG BANG THEORY, 2000
Acrylic and mixed media on panel
25" x 31" x 2"
Private Collection

Dan Clowes

DEVIL SELF-PORTRAIT, c. 1990
Ink & gouache on paper
5 1/2" x 3 1/2"
Glenn Bray Collection

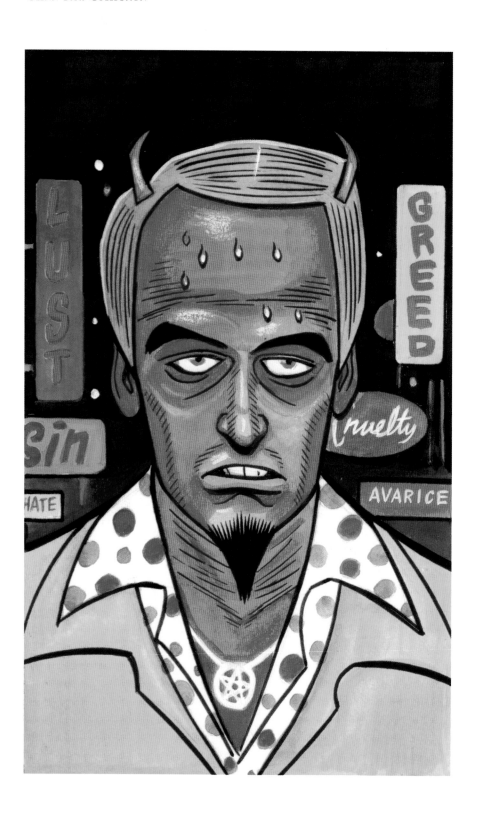

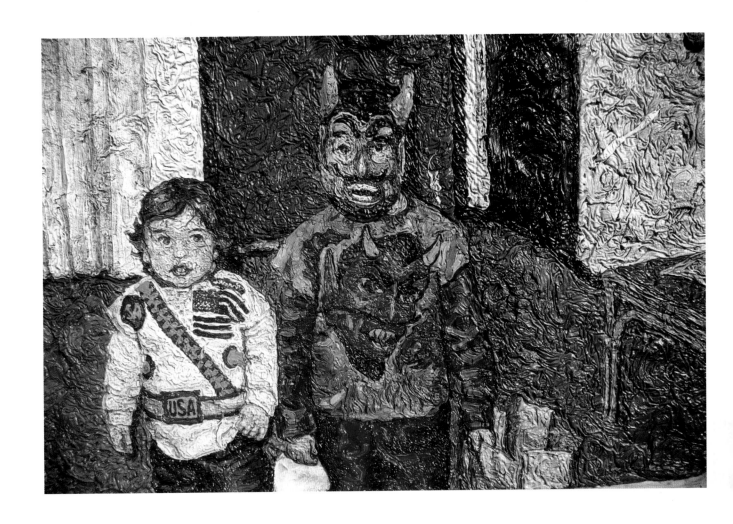

Colin Chillag

GREAT SATAN, 2004
OIL ON CANVAS
20" x 30"
COLLECTION OF CHRISTOPHER ALT AND CHRISTIANA MOSS

Amy Caterina-Barrett

#5 FROM THE MONA SERIES, 2004
Digital photograph
11" x 14"
Collection of Alexander James Harris

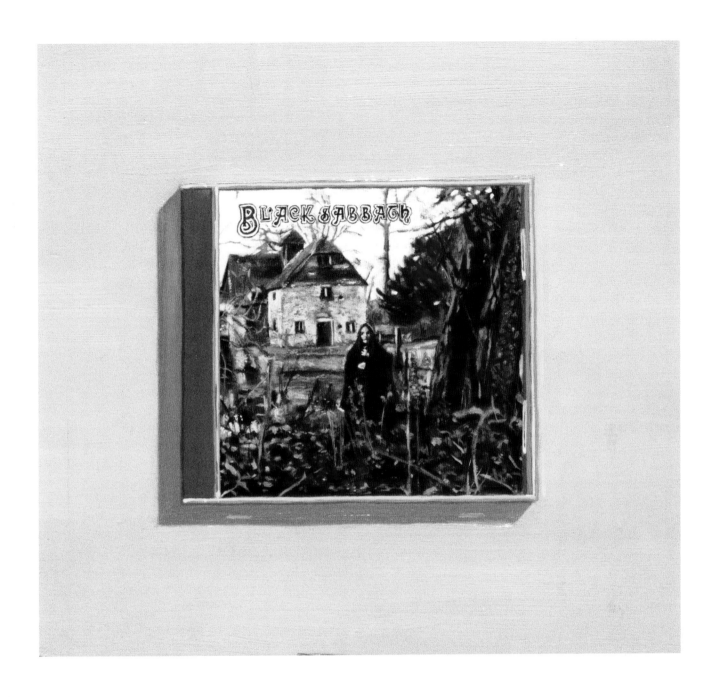

Scott Maruel Cassidy

1ST SABBATH, 2001
Oil on board
9 1/2" x 10 1/2"

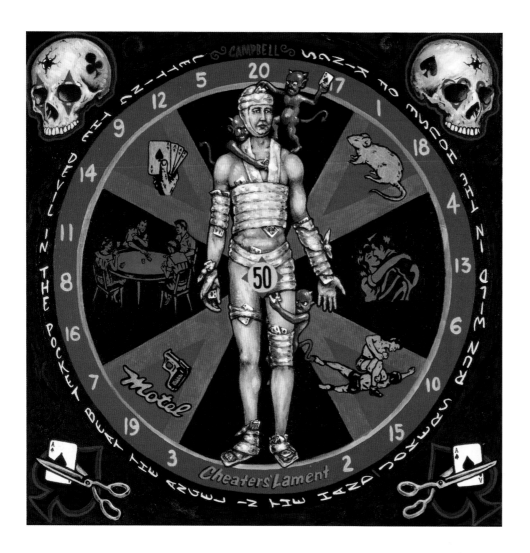

Kalynn Campbell

CHEATERS' LAMENT, 1994
OIL ON CANVAS
24" X 24"
COLLECTION OF GREG AND KRISTIN ESCALANTE
PHOTO BY M.O. QUINN

Bill Burns

BOILER SUITS FOR PRIMATES, 2003
INSTRUMENT SUITCASE WITH MINIATURIZED (1:4)
SET OF EVERYTHING THAT PRISONERS ARE GIVEN WHEN THEY
ARRIVE AT CAMP XRAY IN GUANTANAMO BAY CUBA
28" X 21" X 9"
MUSEUM OF SAFETY GEAR FOR SMALL ANIMALS

PROPOSAL

SECURITY KITS FOR GUANTANAMO BAY
A PROJECT FOR THE HAVANA BIENALE
BILL BURNS 2003

BELOW: EXAMPLES OF ITEMS FOR BLUEPRINT

1. TWO BOILER SUITS (ORANGE)

2. SOAP, SHAMPOO, TOOTHPASTE, MODIFIED TOOTH BRUSH.

3. TWO SHEETS

4. AN 18MM FOAM MATRESS

5. TWO BUCKETS: ONE FOR WATER, ONE FOR WASTE

6. TWO TOWELS: ONE FOR PRAYING, ONE FOR WASHING

7. 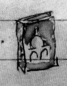 A COPY OF THE KORAN

8. 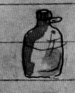 TWO BLANKETS

9. A WATER FLASK

10. 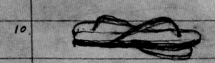 A PAIR OF FLIP-FLOPS

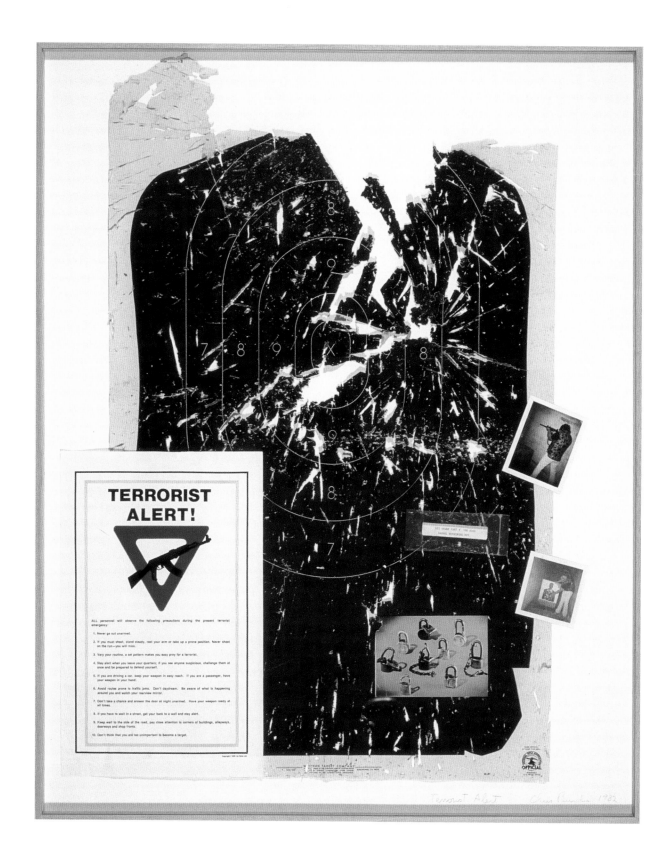

Chris Burden

TERRORIST ALERT, 1982
Collage
40 1/8" x 32"
Collection of Barry Sloane
Photo courtesy Rosamund Felson Gallery, Los Angeles

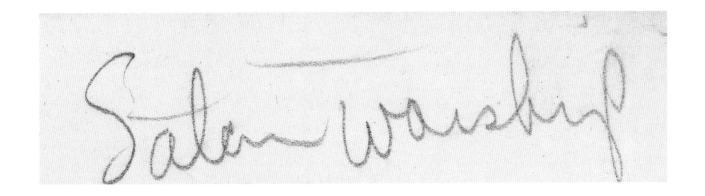

WITCHCRAFT.
133.4 La Vey, Anton Szandor, 1930-
L399 The compleat witch; or, what to do
 when virtue fails. N. Y., Dodd, c1971.

 274 p. col. illus. (on lining papers)

Reference same

 Bibliography: p. [267]-274.

David Bunn

SATAN WORSHIP, 2003
Unique Iris print and L.A. Central Library catalogue card
9 3/4" x 41" print size
3" x 5" card size
Overall dimensions variable
Collection of the Poe's
Courtesy of Angles Gallery, Santa Monica

Jonathan Borofsky

JONNIE HITLER, 1992
MUSIC WRITTEN AND PERFORMED BY JONNIE HITLER
PRODUCED BY JONATHAN BOROFSKY AKA JONNIE HITLER

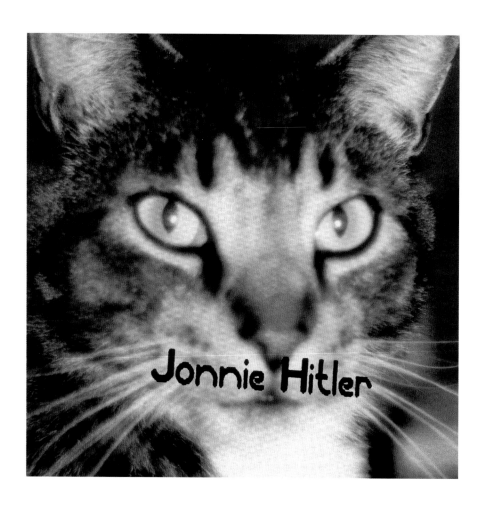

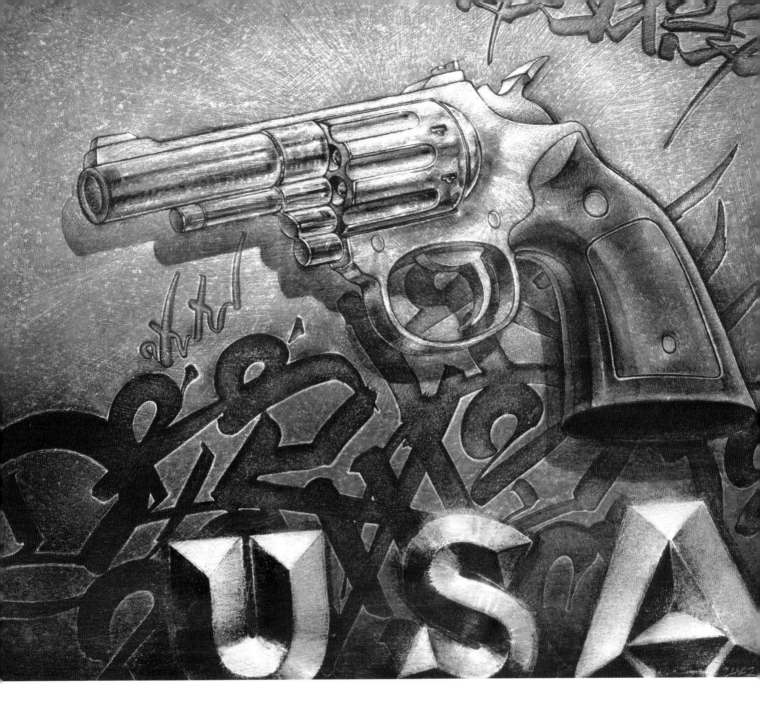

Chaz Bojorquez

EL DESIRE, EL POWER, EL LOVE, 2003
Mixed media
15" x 18"
Copy of original from 1995
Original Collection of Mr. Tommy Marron

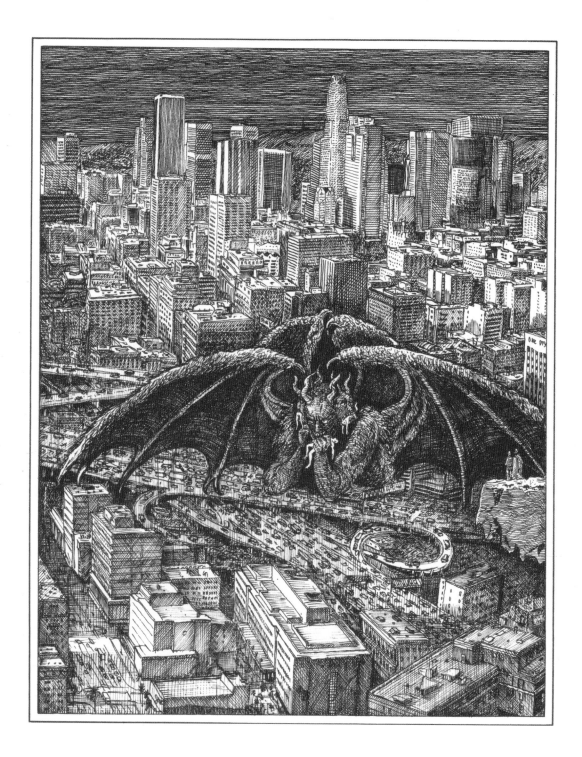

Sandow Birk

DANTE'S INFERNO, 2003
BOOK
11" x 14"
COURTESY OF TRILLIUM PRESS

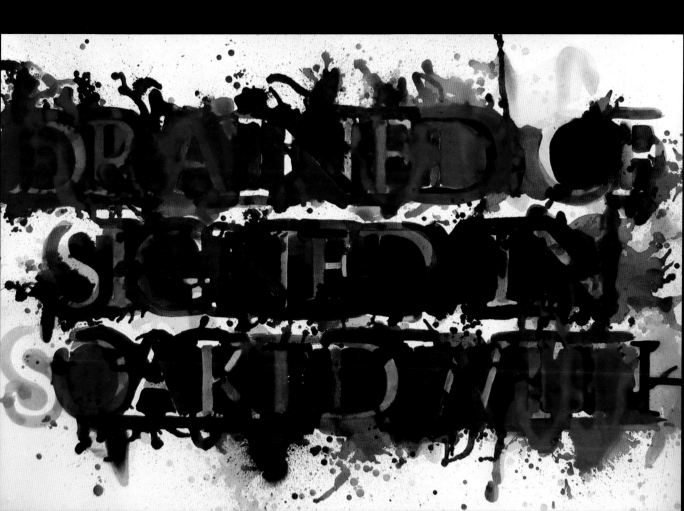

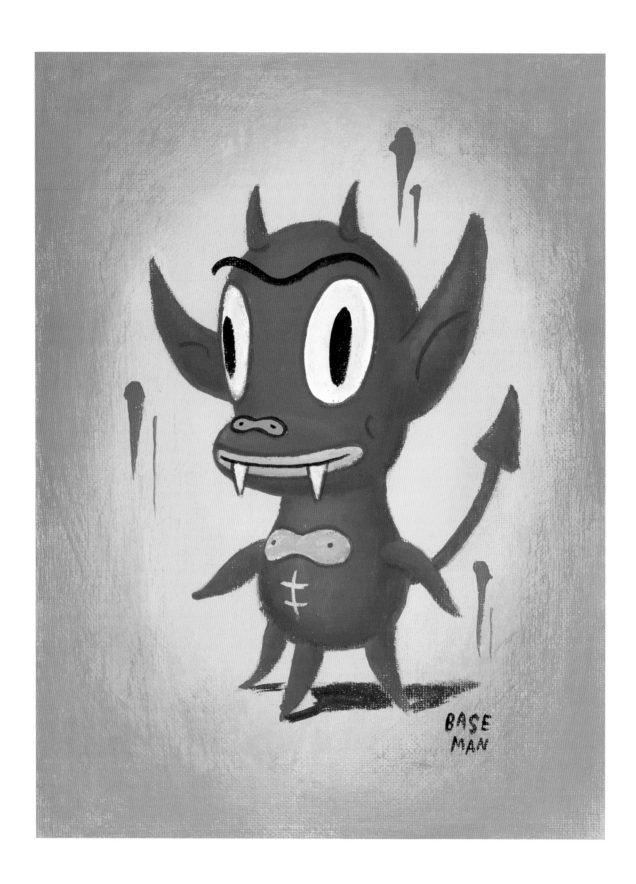

GARY BASEMAN

UNTITLED, 2004
ACRYLIC ON CANVAS
12" x 9"

Van Arno

THE SOUL IS EXTRACTED AND JUDGED BY WEIGHT, 2004
Oil, cell vinyl and egg tempera on wood panel
36" x 24"

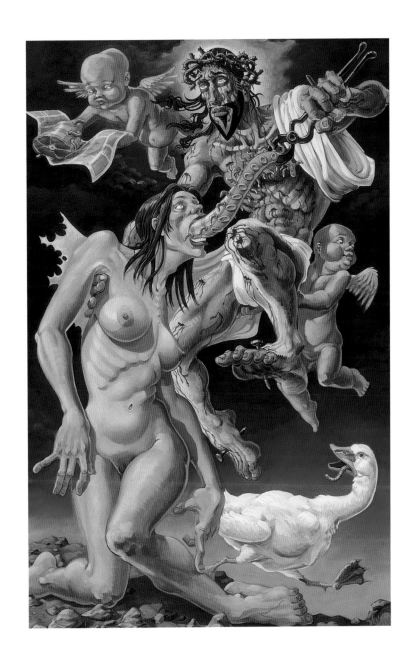

Franco Angeloni

SUBSTANTIAL INTERNATIONAL FINANCIAL AID PACKAGE, 2004
Banknotes and aquarel on paper
36" x 48"

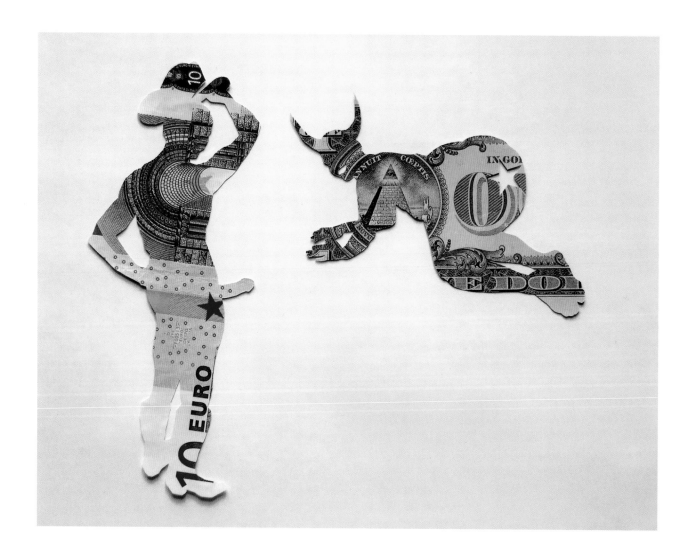

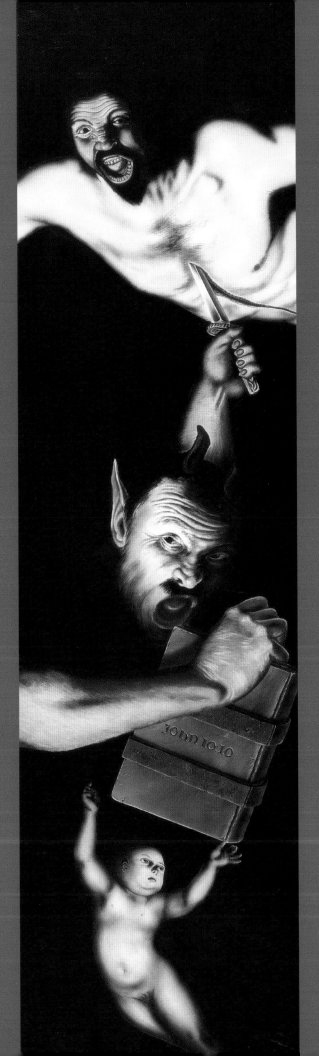

Kevin Ancell

JOHN 10:10, 2000
FOR SALOMON AGAH, SKATEBOARD GRAPHIC
ACRYLIC ON BOARD
27" x 8"
COLLECTION OF SCOTT FLETCHER
PHOTO BY M.O. QUINN

Terry Allen

ALL ARTISTS TRY TO BE GOD AND WILL BURN IN HELL, 2003
Brand on paper
47" x 35"
Courtesy of The John and Maxine Belger Family Foundation

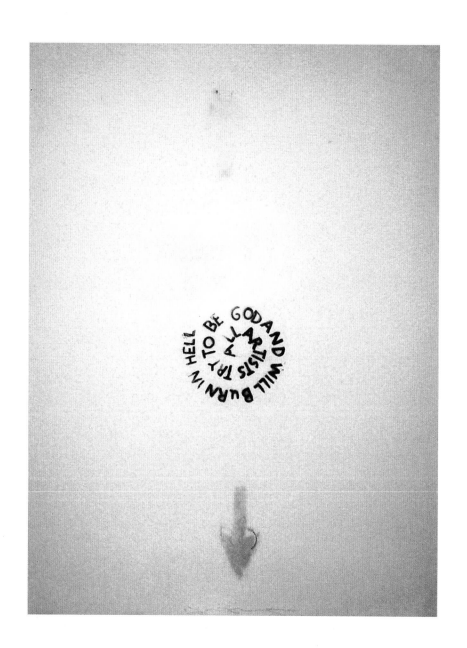

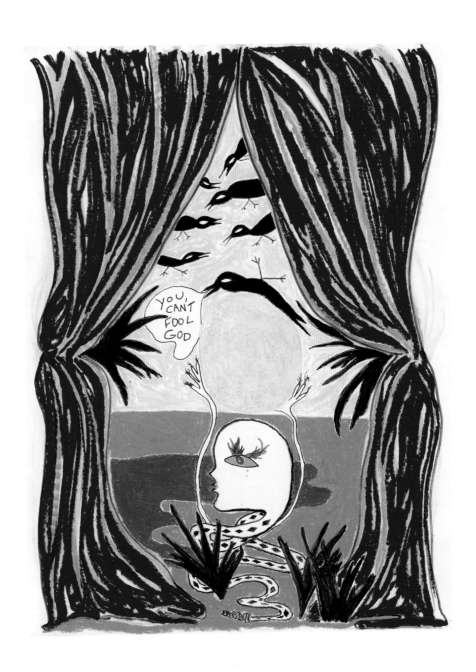

Jo Harvey Allen

UNTITLED, 2004
Oil on panel
23 3/4" x 17 1/2"

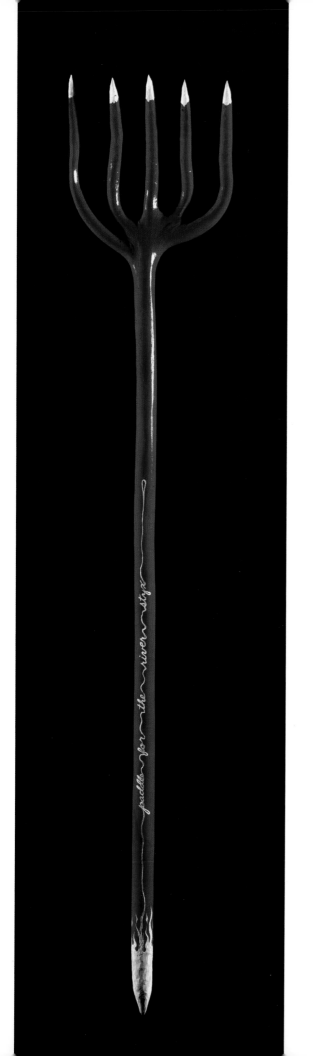

BALE CREEK ALLEN

PADDLE FOR THE RIVER STYX, 2003
54" x 10" x 6"
CARVED WOOD AND ENAMEL
PHOTO BY MATTHEW FULLER

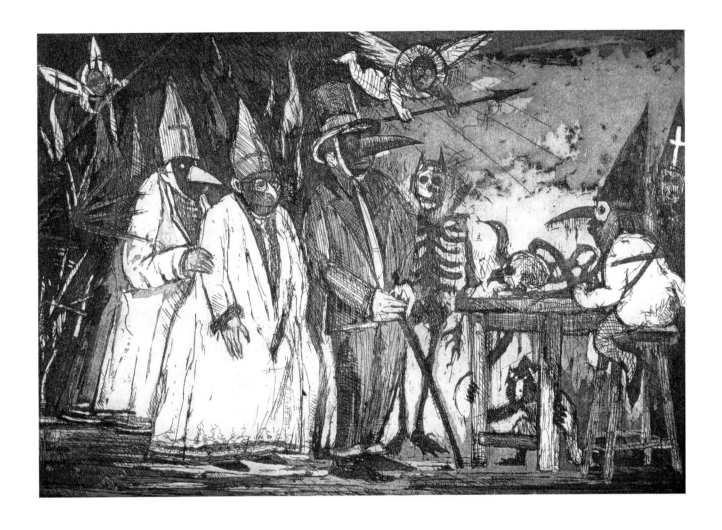

John Alexander

THE TRIAL, N.D.
Etching
9" x 12"
Collection of Greg and Kristin Escalante
Photo by M.O. Quinn

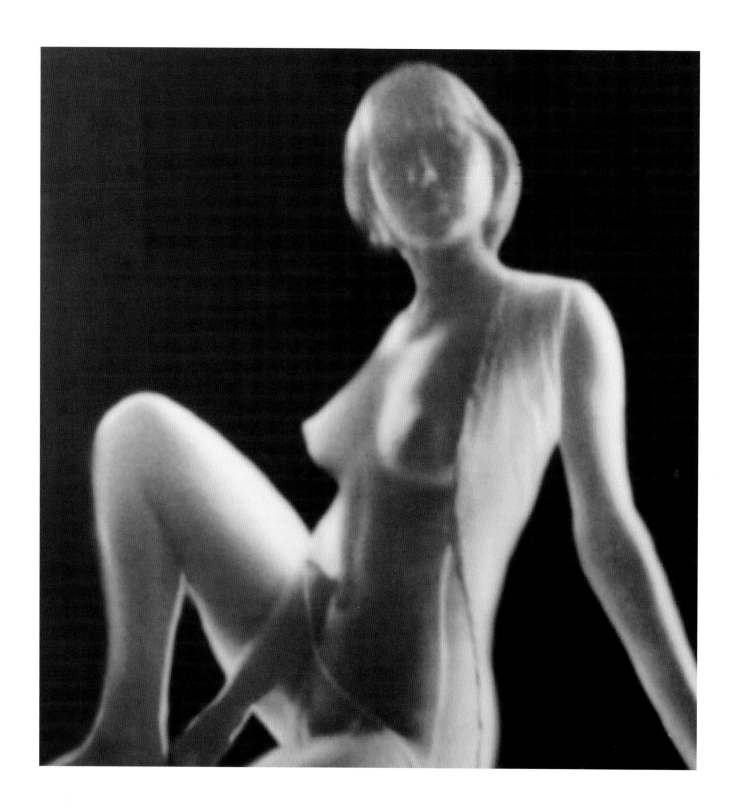

Peter Alexander

STEPHANIE, 2001
Digital print on velvet
9 1/2" x 9"
Edition 3/10
Courtesy of Craig Krull Gallery, Santa Monica

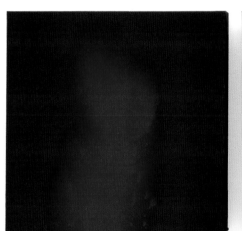

Lita Albuquerque

IGNITION, 2003
Triptych
Powder pigment on panel
15" x 15" x 3 1/2" each panel

Reverend Ethan Acres

DIE, SATAN, DIE, 2001
Sculpey
14" x 12" x 12"
Collection of Barry Sloane

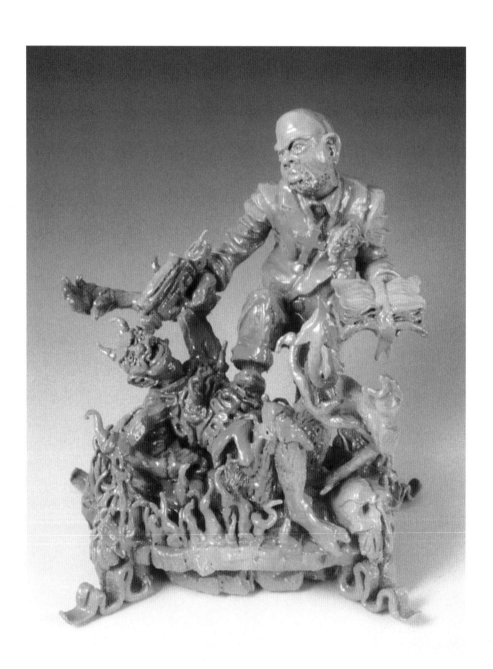

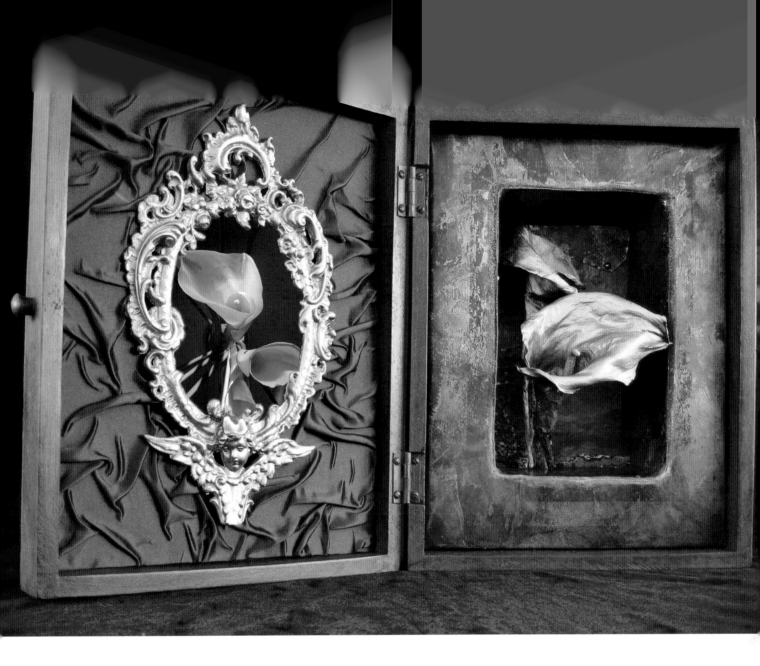

Kim Abeles

THE PASSION OF SATAN, 2004
Mixed media
13" x 20 1/2" x 5 1/2"

God bless those pagans.

Homer Simpson

"But then I sigh, and with a piece
of scripture, tell them that God bids us
do good for evil. And thus I clothe my
naked villainy with odd old ends stolen
forth of holy writ, and seem I a saint,
when most I play the Devil."

William Shakespeare
King Richard III

"Glory and praise to you, Satan, in the heights of heaven where once you reigned, and in the depths of hell where, vanquished, you dream in silence. Grant that my soul, some day, may rest beside you, under the Tree of Knowledge, at the hour when on your brow, like a new temple, its branches will spread!"

Baudelaire,
The Litanies of Satan, 1846

CALIFORNIA STATE UNIVERSITY FULLERTON
GRAND CENTRAL ART CENTER
Andrea Lee Harris, Dennis Cubbage, Amy Caterina-Barrett, Rebecca C. Banghart, Scott Stodder,
David Michael Lee, Eric Jones, Scott Hilton, Brett Caterina-Barrett, and Frank Swann

GRAND CENTRAL ART FORUM
Greg Escalante, Shelley Liberto, Mitchell De Jarnett, Marcus Bastida, Teri Brudnak, Lisa Calderone,
Don Cribb, Jon Gothold, John Gunnin, Mary Ellen Houseal, Dennis Lluy, Mike McGee, Stuart Spence,
Ren Messer, Advisory Members, Peter Alexander, Rose Apodaca Jones, Kristin Escalante,
Mike Salisbury, Anton Segerstrom, and Paul Zaloom

CALIFORNIA STATE UNIVERSITY FULLERTON
President, Milton Gordon, Dean, Jerry Samuelson, Marilyn Moore, and Bill Dickerson

This edition published by Last Gasp of San Francisco and California State
University Fullerton Grand Central Art Center. This book had been
published in conjunction with *100 Artists See Satan* curated
by Mike McGee for the exhibition at Grand Central Art Center,
Santa Ana, California, where it was presented 3 July – 19 September, 2004.
The exhibition and book where made possible by generous support of
Grand Central Art Forum, CSUF Grand Central Art Center,
Cal State University Fullerton, Stuart and Judy Spence and Last Gasp.

Editor: Sue Henger
Art Director: Theron Moore
Designers: Josh Barney, Andrea Herbold, Brian Lindstrom, Eric Lumba, Tanya A. Ortega, and Erik Nagashima
Photography: All photographs courtesy of the artist unless otherwise noted
Printed by: Prolong Press, Hong Kong

100 Artists See Satan

LAST GASP
777 Florida Street
San Francisco, California 94110
415-824-6636
www.lastgasp.com

GRAND CENTRAL PRESS
CSUF Grand Central Art Center
125 N. Broadway, Suite A
Santa Ana, California 92701
714-567-7233 714-567-7234
www.grandcentralartcenter.com

ISBN: 0-86719-666-1